TEXAS *Wildflowers*

impressions

photography and text by
Rob Greebon and Richard Reynolds

FARCOUNTRY
PRESS

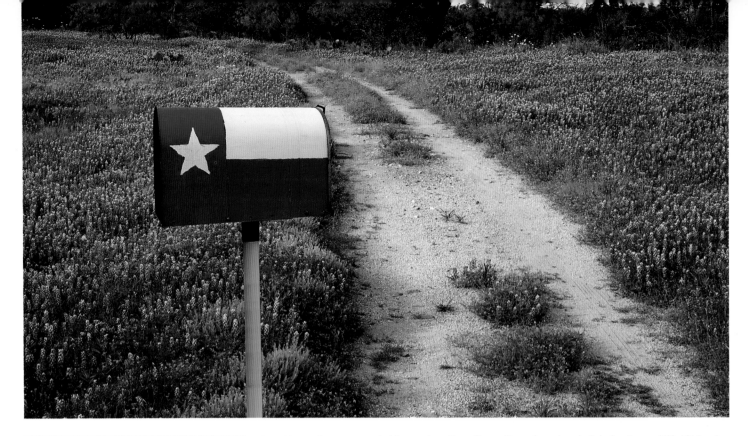

> *To Andrea, who has walked with me before sunrise, after sunset, and all times between.*
> — *Rob Greebon*

ISBN: 978-1-56037-675-0

© 2017 by Farcountry Press
Photography © 2017 by Rob Greebon
Photography © 2017 by Richard Reynolds
Text by Rob Greebon and Richard Reynolds

For more information about our books, write Farcountry Press, P.O. Box 5630, Helena, MT 59604; call (800) 821-3874; or visit www.farcountrypress.com.

Produced in the United States of America.
Printed in China.

21 20 19 18 17 1 2 3 4 5 6

Above: I've seen several of these unique, Texas-flag mailboxes in my travels. But when I passed this Hill Country mailbox with the Lone Star emblazoned on it and a trail leading through bluebonnets in the background, I had to stop and photograph the rural scene. Rob Greebon

Facing page, top: This Texas bluebonnet *(Lupinus texensis)* image is one of a series of high-resolution images I made of more than a hundred flowers several years ago. They were all done in the studio so that I could control movement and lighting, since it took seventy-two separate exposures, which all had to be in perfect alignment. The final image is well over five by seven feet. Richard Reynolds

Title page: One of the best wildflower blooms I've ever seen was in 1997. I was driving along one of my favorite South Texas routes when I came upon this majestic oak tree in a field of Sandyland bluebonnets *(Lupinus subcarnosus)* and white pricklypoppies *(Argemone albiflora var. texana)*. The sun was setting, and I was able to set up my 4x5 camera and get the shot just in time. Richard Reynolds

Front cover: Just south of Marble Falls, this field of bluebonnets seems untouched by man. Only a few miles from here, locals took family photos in another field of bluebonnets. Fortunately for me, word had not gotten out about this nearby location. I did not see another person for two hours. Rob Greebon

Back cover: Plentiful rains in fall and winter create a spring wonderland of blooming cacti, such as this cane cholla *(Cylindropuntia imbricata var. imbricata)* in the lower desert of Big Bend National Park. I photographed this specimen in mid-April, which is usually peak bloom time for Big Bend cacti, although you can usually find one or more species blooming in every month of the year. Richard Reynolds

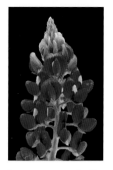

INTRODUCTION

by Richard Reynolds

Wildflowers have been in existence since the Cretaceous period of Earth's history, about 160 million years ago, but experts believe that the vast majority of species that prospered back then are now extinct.

All flowering plants belong to the classification known as angiosperms, of which there are more than 295,000 known species worldwide. Like gymnosperms, which produce seeds on cones or leaves, angiosperms also produce seeds but do so with their flowers, which in turn produce seed-containing fruits.

Today, the diverse environments and climates found within the borders of Texas are home to at least 5,000 blooming plant species. This number represents one-quarter of all the flowering plants in the United States and includes not just the native bluebonnets, paintbrush, and sunflowers we all know and love, but also trees, shrubs, grasses, sedges, vines, and xerophytes such as cacti and succulents.

Most people refer to wildflowers by their common names, but botanists strive to be more precise, using the binomial Linnaean system that assigns each plant a genus and species name. For instance, the common name "prickly pear cactus" can refer to fifteen different species that share the genus name *Opuntia*.

The common name "Texas bluebonnet" is another example. While most people think of the Central Texas bluebonnet, *Lupinus texensis,* as the official state flower, the Texas legislature actually designated *Lupinus su carnosus* as the state flower back in 1901. But four other bluebonnets also grow in the state: *L. havardii, L. concinnus, L. perennis,* and *L. plattensis,* and in 1971 Texas lawmakers declared all six species to be the official state flower.

In Texas, blooming plants are found from sea level along the Gulf Coast to almost 9,000 feet at Guadalupe Peak. Elevation is but one factor that influences where plants grow and thrive. Also important are landform, climate, annual days below freezing, and rainfall. These factors combine to carve Texas' 268,000 square miles into nine vegetational regions, each home to a distinct array of wildflowers.

TEXAS' 9 VEGETATIONAL REGIONS

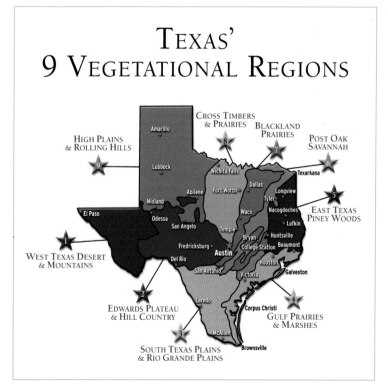

3

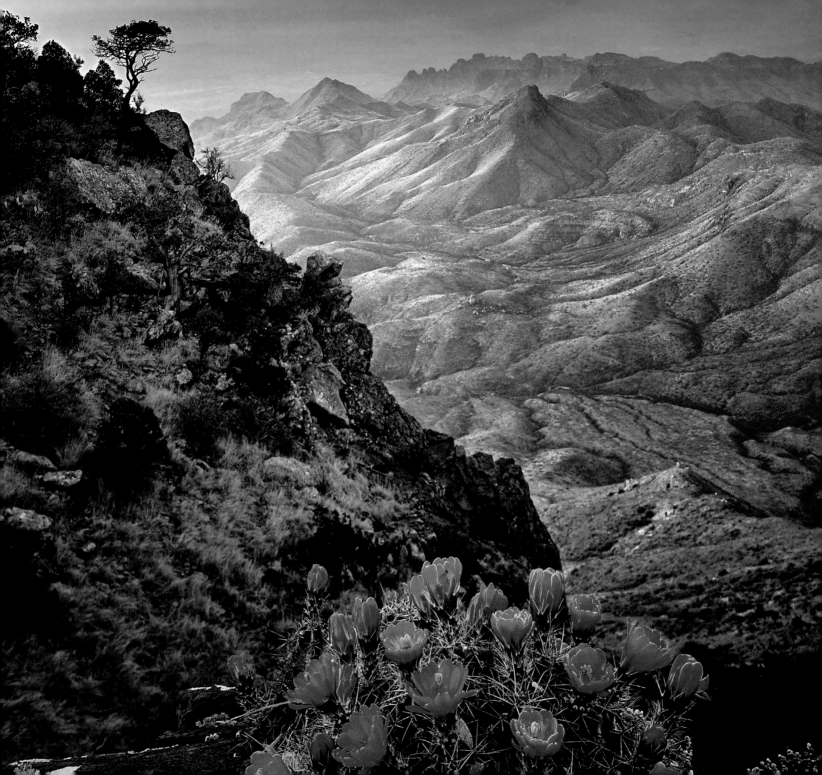

1 WEST TEXAS DESERT & MOUNTAINS

Stretching from the Pecos River west to El Paso and north to the New Mexico border, this region is characterized by arid deserts and montane forests, where precipitation averages between seven and twenty inches a year. Plants such as cacti have adapted to this meager amount of moisture by evolving characteristics to hold in water for the extended dry periods. Most of the precipitation falls as rain during summer, but winter brings some ice and snow. Grasses in the region are sparse and desert vegetation prevails, including cacti, creosote, agaves, mesquite and juniper trees, cenizo, and other xerophytes (plants with specialized tissues for storing water).

Because of the short rainy season, plants sprout and desert hillsides and flats green up and begin flowering soon after rains fall. The summer bloom in Big Bend National Park is usually much showier than the spring bloom, which is dependent on uncommon winter storms that usually don't bring significant precipitation.

When it does rain, among the first to bloom are bicolor mustard, woolly mat, and bladderpod. Following soon after are the yuccas, Big Bend bluebonnets, pineapple cactus, Warnock's cactus, and agarita. Summer rains herald the arrival of purple sage flowers, giant fishhook cactus, climbing milkweed, and palmleaf thoroughwort. In the Davis Mountains you can find esperanza, scarlet bouvarida, paintbrush, milkpea vine, American basketflower, and cane cholla at their best from June through August. Spectacular displays of Mexican gold poppies occur in March after rainy winters in the Franklin Mountains near El Paso.

2 EDWARDS PLATEAU & HILL COUNTRY

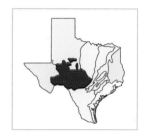

Located just east of the Pecos River and extending to the Blackland Prairies Region, the Edwards Plateau is a rolling to hilly landscape with limestone outcrops and thin soils. A series of steep canyons carved by meandering rivers flowing into the Gulf of Mexico cut through the region.

Near the center of the Edwards Plateau is the Llano Uplift, an area with ancient granite formations and sandy soils. Enchanted Rock, a billion-year-old batholith made of solid granite, is the prominent feature here. The soils of the Edwards Plateau range from chalky to sandy or clayey. The dominant trees are Ashe juniper, mesquite, and live oak. Along the larger rivers, such as the Guadalupe in Kerrville State Park, bald cypress and pecan trees flourish. Common

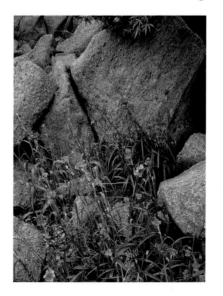

Left: Spiderwort *(Tradescantia sp.)* adds a sharp color contrast with the lichen-encrusted granite boulders of Enchanted Rock State Natural Area. Richard Reynolds

Facing page: A blooming claret cup cactus *(Echinocereus coccineus var. paucispinus)* adds a splash of color to the desert landscape of Big Bend National Park. Perhaps the grandest scene in all of Texas may be had from the South Rim of the Chisos Mountains, accessible only after a seven-mile hike uphill. Add a blooming cactus and it's a truly stunning view. Richard Reynolds

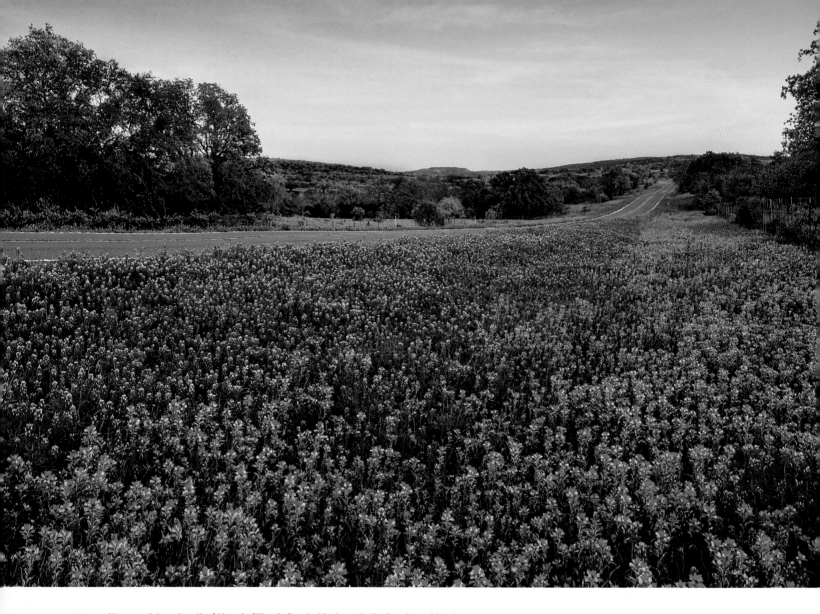

Above: Along a quiet road north of Llano in Gillespie County, bluebonnets *(Lupinus texensis)* and Indian paintbrush *(Castilleja indivisa)* filled the roadsides in the spring of 2016. Vast stretches of this highway offered colors of red and blue around every corner. For a week or so, this was one of the most beautiful drives in Texas. Rob Greebon

Facing page: Bluebonnets *(Lupinus texensis)*, winecups *(Callirhoe involucrata),* and yellow flax *(Linum berlandieri var. berlandieri)* put on a show of color in Gonzales County. Richard Reynolds

wildflowers, such as the Texas bluebonnet, which thrives in poor soils, can be seen in abundance at Inks Lake State Park near Burnet, and McKinney Falls State Park south of Austin.

In most of the Hill Country, one can find bluebonnets in massive displays along roadways and in fallow fields during good years. From late March until mid-June, State Highway 71 from Llano to Brady is undoubtedly one of the most spectacular wildflower drives in the state. The spring bloom begins with Indian paintbrush mixed in with blue-bonnets. The show intensifies in March, with Indian blanket, prairie verbena, pink evening primrose, greenthread, goldenwave, and Mexican hat flowering in unison. Almost all the roads around the Highland Lakes near Marble Falls, Horseshoe Bay, and Kingsland are awash in bluebonnets in spring. Plentiful rains beginning in October and continuing throughout winter ensure a good bloom. In years where the rare snow or ice storm blows through, it seems to be even better.

 ## SOUTH TEXAS & RIO GRANDE PLAINS

The southernmost region of the state is a mostly flat landscape with a mild, semi-arid climate and rainfall of twenty to thirty inches a year. Although much of this region has been cleared for agriculture, it was originally densely covered with thorny shrubs, cacti, and small to medium trees growing on loamy, clay soils. The Tamaulipan thornscrub, or chaparral, as people sometimes call it, still exists in patches, interspersed between farmlands. Shrubs such as guajillo, blackbrush acacia, cenizo, and catclaw,

mixed with extensive stands of prickly pear, sometimes form an impenetrable barrier to travel.

The Coastal Plains Region serves as the boundary for the eastern portion of the South Texas Plains, and the Rio Grande defines the western edge. U.S. Highway 90, which passes through San Antonio and Del Rio, roughly defines the northern boundary. The southern-most section, the Rio Grande Valley, has a semi-tropical climate and has been adapted for farming due to the mild winter temperatures, deep soils, and heavier rainfall. Pockets of the original chaparral remain in preserves such as Chihuahua Woods Preserve and in parks such as Bentsen-Rio Grande State Park. Common grasses on the Rio Grande Plains include windmill grass, silver bluestem, buffalograss, Arizona cottontop, Texas cupgrass, and various gramas.

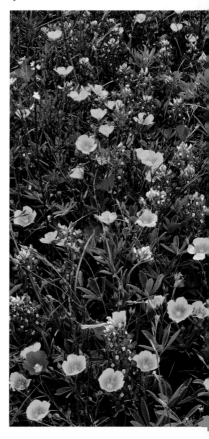

South Texas wildflowers are not as well-known as their Hill Country counterparts, but they are capable of displays every bit as spectacular. Sand verbena, winecup, Indian blanket, sandyland bluebonnet, Drummond phlox, Texas lantana, Mexican hat, tropical sage, and mountain laurel can be seen along I-35 between San Antonio and Laredo, I-37 from San Antonio to Corpus Christi, and State Highway 16 between Poteet and Hebbronville.

GULF PRAIRIES & MARSHES

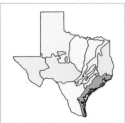

Barely reaching 100 feet in elevation at its highest point, this region stretches in a broad arc from the southernmost tip of Texas near Brownsville to the Louisiana border near Port Arthur. With the mildest climate in the state of Texas, this region averages sixty inches of rain near Beaumont to twenty-six inches at South Padre Island. Freezes are uncommon, although arctic fronts sometimes make their way through the area and even drop snow and ice on rare occasions.

Saltgrass marshes, tallgrass prairies, and dense stands of oak trees (oak mottes) typify the diverse vegetation of the inland portion of the region. On Padre Island National Seashore, which stretches from Port Isabel to Corpus Christi, nearly 400 plant species have been identified. Perhaps the most flamboyant bloomer along the coast, railroad vines (also called goat's foot morning glory) begin to open their showy magenta flowers in June. They are frequently mixed in with white, less showy, and smaller-flowered beach morning glories. Both can be seen at Mustang Island State Park, just south of Port Aransas. Yellow, orange, and red prickly pear blossoms are on display at Laguna Atascosa National Wildlife Refuge near Brownsville farther inland, while huisache and mesquite trees, bitter sneezeweed, broomweed, false dragonhead, sea oxeyes, silverleaf sunflower, phlox, Indian blanket, and Mexican hat grow on the plains and in bottomlands. Good examples can be seen in Brazos and San Bernard National Wildlife Refuges south of Houston, and Anahuac and McFaddin National Wildlife Refuges between Galveston and Port Arthur.

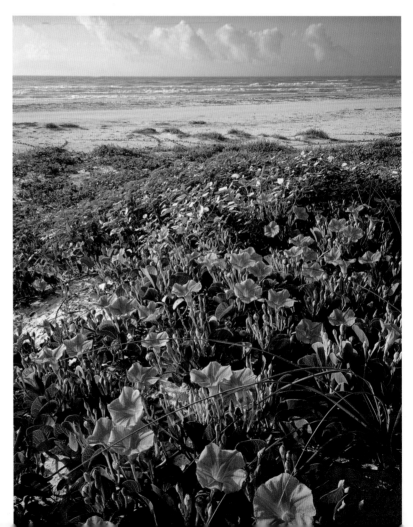

Right: Texas is not generally known for big wildflower displays in summer, but along the Gulf Coast, as seen here at Padre Island National Seashore, the striking blossoms of railroad vine flowers (*Ipomoea pes-caprae*) are at their peak from mid-June through mid-July. Richard Reynolds

Facing page: A blooming dogwood tree (*Cornus florida*) brightens the dense forest in Big Thicket National Preserve. Richard Reynolds

 # 5 EAST TEXAS PINEY WOODS

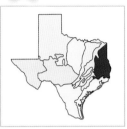

Lying at the western edge of the southern pine forest that extends all the way to the Atlantic seaboard, the East Texas Piney Woods Region is characterized by pine and hardwood forests, humid swamps, and gently rolling prairies. With forty to sixty inches of rainfall annually, this is the greenest region of Texas. Oak, magnolia, hickory, sweetgum, tupelo, dogwood, and elm trees, along with three species of pines, populate the area.

Unique plant communities such as sundews, pitcher plants, bladderworts, and butterworts exist within the Big Thicket National Preserve near the towns of Woodville, Kountze, Saratoga, and Beaumont. Many other terrestrial and aquatic plant species, mosses, lichens, and fungi thrive in the fertile environment. Common wildflowers are crimson clover, lanceleaf coreopsis, dayflower, spiderwort, sensitive briar, phlox, Carolina spiderlily, and several orchid species. Beautiful American lotus and water lily blossoms are on display at Caddo Lake State Park in summer. Blooming trees in the region include flowering dogwood, white fringetree, cherry laurel, hog plum, and southern magnolia. Woodville and Palestine celebrate dogwood festivals on the last two

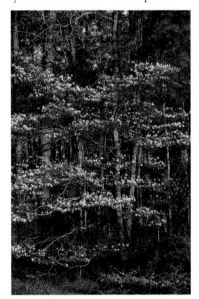

weekends in March and the first weekend in April. The towns of Avinger, Hughes Springs, and Linden host a signed wildflower route on the last weekend in April, with yellow-fringed orchid, lobelia, coral bean, coreopsis, Indian paintbrush, phlox, crimson clover, and many other species on full display. In Newton County near the Louisiana border, the Wild Azalea Canyons are home to groves of prolific blooming native shrubs that produce clusters of spectacular pink flowers.

 # 6 POST OAK SAVANNAH

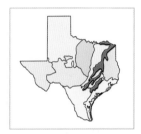

Located between the Piney Woods and the Blackland Prairies, this part of Texas possesses characteristics of the pine forest on its eastern side and some qualities of the prairie on its western portion. The main section of the Post Oak Savannah runs from east of San Antonio, northeast to Texarkana, and then along the Red River in a narrow belt for about eighty miles. The second section is an island butting up against the coastal plain on its southeastern edge, with the Blackland Prairies bordering its northwestern edge.

Farming and ranching have altered the original character of the area, as they have in most of Texas. Higher-elevation soils are usually sandy loam, while lower elevations have various loams mixed with clays. Some isolated areas have blackland soils. Much like South Texas, the present-day Post Oak Savannah is a patchwork of native grasslands and woodlands mixed with farmland and ranchland. Wintergrass, switchgrass, silver bluestem, big bluestem,

spike and longleaf woodoats, and indiangrass originally prospered in the grasslands here. Post oak and blackjack oak are the dominant trees, but tangled, shrubby plants such as greenbriar (*Smilax*) and yaupon now form dense thickets in the woodlands, mainly due to overgrazing.

Palmetto State Park between Luling and Gonzales has beautiful blooms of giant spiderwort, wild blue iris, and red buckeye in spring. U.S. Highway 183 between Austin and Goliad is one of the best wildflower drives in Texas, with green-flowered milkweed, black-eyed Susan, southern wild senna, Drummond phlox, Texas wisteria, beautiful false dragonhead, chickweed, sandyland bluebonnet, and coral honeysuckle creating extravagant shows from March through May.

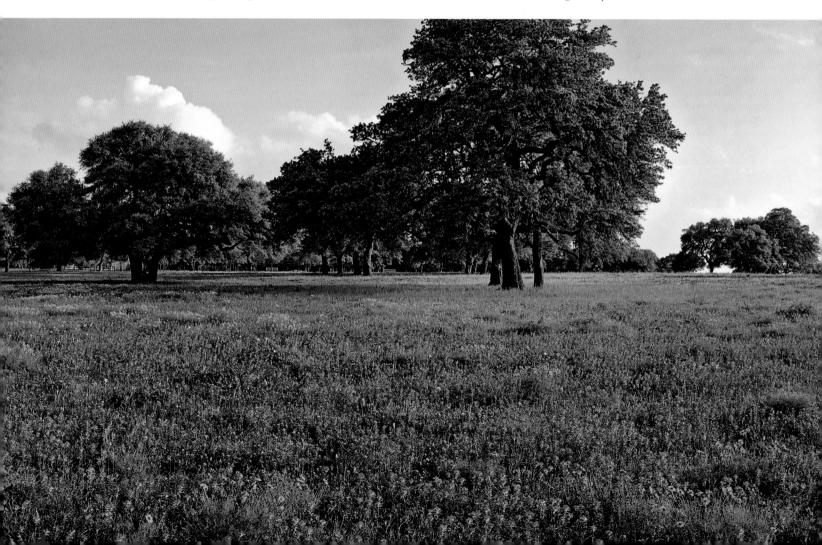

BLACKLAND PRAIRIES

This region consists of a long finger of land running from the Red River to near San Antonio, and two land islands sandwiched between the Cross Timbers Region and the Post Oak Savannah Region. It is part of a vast prairie that once extended from the Texas coast to Manitoba, Canada. The Blackland Prairies Region is blessed with deep, fertile dark clays and sandy loams that once supported an extensive tallgrass prairie. Big bluestem, little bluestem, indiangrass, and switchgrass were once dominant here, but because of its favorable climate and highly arable soils, the land was converted to agricultural uses, eliminating many of the native prairie grasses.

Elevations range from 200 to 800 feet, and the land is either slightly rolling or nearly level. Oak, pecan, osage orange, and elm trees grace the streambanks and riverbanks here. Non-native mesquite trees have found their way into the former grasslands and are now common. Texas grama and buffalograss have invaded most of the original tallgrass prairie, with only a few native pockets remaining, such as the Clymer Meadow Preserve near Greenville and Blackland Prairie Park in Arlington.

Wildflowers in the Blackland Prairies are abundant and diverse: winecup, Indian paintbrush, common yarrow, butterfly weed, purple coneflower, Texas bluebells, prairie penstemon, and mealy blue sage do well in the fertile soils here. One of the most legendary bluebonnet drives in Texas winds around the towns of Brenham and Chappell Hill. Vast stands of Texas's state flower carpet fields and pastures, sometimes mixed in with Indian paintbrush.

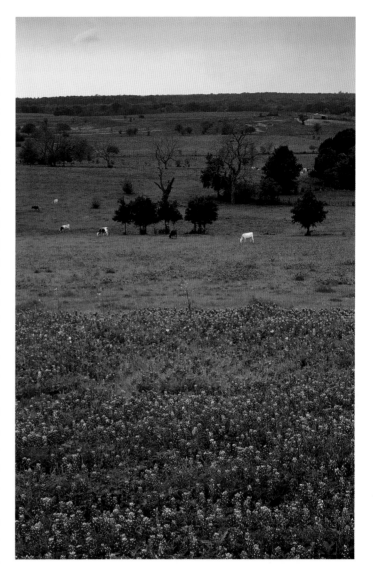

Above: Bluebonnets share a pasture with livestock in Washington County. Richard Reynolds

Facing page: Live oak trees loom behind a scattering of Indian paintbrush (*Castilleja indivisa*), bluebonnets (*Lupinus texensis*), and greenthread (*Thelesperma filifolium*) in Fayette County. Richard Reynolds

8 CROSS TIMBERS & PRAIRIES

9 HIGH PLAINS & ROLLING HILLS

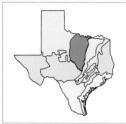

This region lies between the High Plains & Rolling Hills to the west, the Blackland Prairies on the east, and the Edwards Plateau to the south. Here the geological formations, soil composition, and plant life are diverse. Dense woodlands with shrubby undergrowth form on sandy, loamy soils, and prairies feature post oak, blackjack oak, cedar elm, hickory, bois d'arc, mesquite, and juniper. Some of these trees have invaded the region due to past fire suppression efforts. Groundcover includes tallgrass and shortgrass species such as big bluestem, little bluestem, indiangrass, switchgrass, sideoats grama, hairy grama, tall grama, and buffalograss. Texas Indian mallow, common yarrow, scarlet buckeye, and Berlandier's sundrops are but a few of the many wildflowers that thrive in places like Possum Kingdom Lake and Dinosaur Valley State Park. Golden smoke and fringed puccoon are common on the sandy and clayey soils of the region. Coneflower, Indian blanket, and smartweed grow at Hagerman National Wildlife Refuge and in areas around Lake Texoma north of Sherman and Denison.

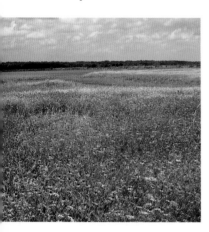

Above: Woolly paperflower *(Psilostrophe tagetina)*, Indian blanket *(Gaillardia pulchella)*, and plains blackfoot daisy *(Melampodium leucanthum)* bloom at Hagerman National Wildlife Refuge.
Richard Reynolds

Facing page: Horsemint *(Monarda citriodora)*, Indian blanket, and woolly paperflower fill the canyon floor in Palo Duro Canyon State Park in June.
Richard Reynolds

The Great Plains & Rolling Hills Region extends south from Oklahoma through Amarillo and Lubbock, down to the northern edges of the Edwards Plateau and the Desert & Mountains Region, and east to the Cross Timbers Region. Annual rainfall here is between ten and twenty inches, and what precipitation falls is held in ephemeral, shallow lakes known as playas, or it percolates through porous soils to replenish aquifers. The Canadian River, which cuts across the Texas Panhandle from east to west, is the largest drainage in the northern part of the region, and the Colorado, Brazos, Red, and Trinity Rivers divide the eastern portion.

The High Plains are virtually treeless, but native grasses still thrive in a significant part of the region, including little bluestem, western wheatgrass, indiangrass, switchgrass, sand reed grass, blue grama, and buffalograss. Other plants commonly found here are prickly pear cactus, honey mesquite, yucca, sand sagebrush, and shinnery oak.

Plains wildflowers mostly bloom in summer and fall. After the coldest winters have passed and the last snow and ice storms have blown through, and daytime temperatures have warmed into the 80s, Indian blanket, plains paperflower, and lemon horsemint begin to pop up in places like Palo Duro Canyon State Park south of Amarillo, and Lake Meredith National Recreational Area west of Borger.

Fall bloomers such as wreath aster, Maximillian sunflower, and dotted gayfeather color roadsides and fields after the summer bloomers have faded, and broom snakeweed begins to pop up like giant, yellow pom-poms in fields and other open spaces.

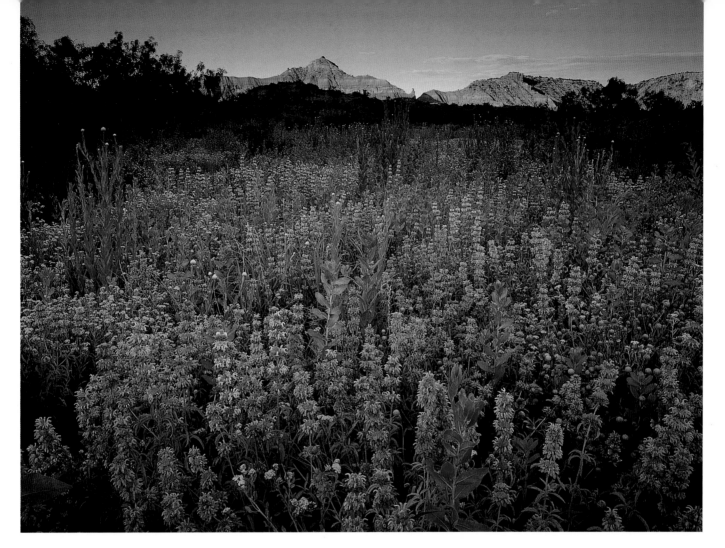

In an age when more and more people are moving to cities and wild areas are bulldozed for commercial, agricultural, and residential development, there are some things we can do to help preserve our native plants.

Take a drive and experience firsthand the abundance and beauty of Texas wildflowers. Remember that they are not just there for our viewing pleasure—they furnish food and habitat for wildlife, they guard against soil erosion, and many have potential value for medicinal purposes.

Grow native plants in your own garden and avoid introducing non-native species that are known to be invasive, as they can upset the balance of ecosystems.

Support efforts of conservation organizations such as the Lady Bird Johnson Wildflower Center and The Nature Conservancy, whose mission is to protect and preserve our native plants and natural landscapes. Doing these things can help ensure native plants will still be around for generations to come.

Previous pages: This sea of bluebonnets represents one of the most perfect evenings I've experienced as a photographer. With my dad along with me on this trip on the edge of the Hill Country near San Saba, we found several large fields of bluebonnets under a sky just released from a storm, in full pink and orange. The air was completely still, and the only sounds were cows mooing in the distance. I had not come across such a landscape in many years, making this moment akin to finding the pot of gold, only made richer by experiencing it with my dad. Rob Greebon

Right: Big Bend has its own species of bluebonnets *(Lupinus havardii)*. With Cerro Castellan looming in the distance, bluebonnets rise to greet the sun on a cold March morning. I shot in this area for an hour and never saw another person. It's been said that Big Bend is not a stop on the way to anywhere else; it is a destination. Rob Greebon

Below: Texas rainbow cactus *(Echinocereus dasyacanthus)* decorate this rocky patch in Big Bend National Park. Richard Reynolds

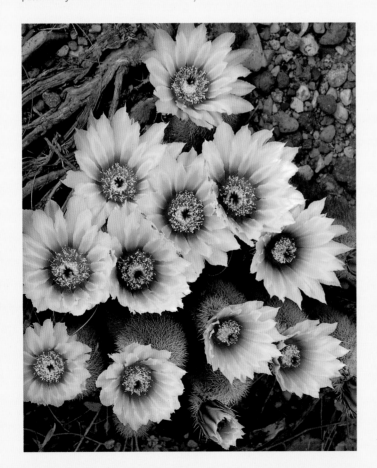

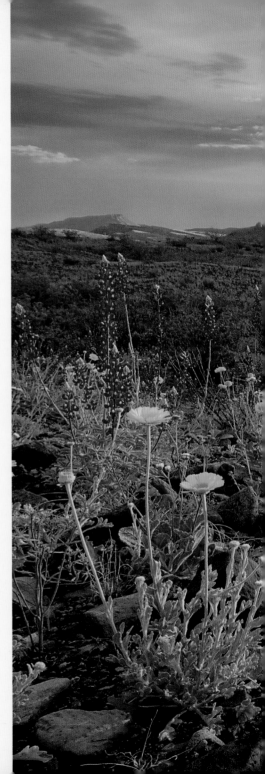

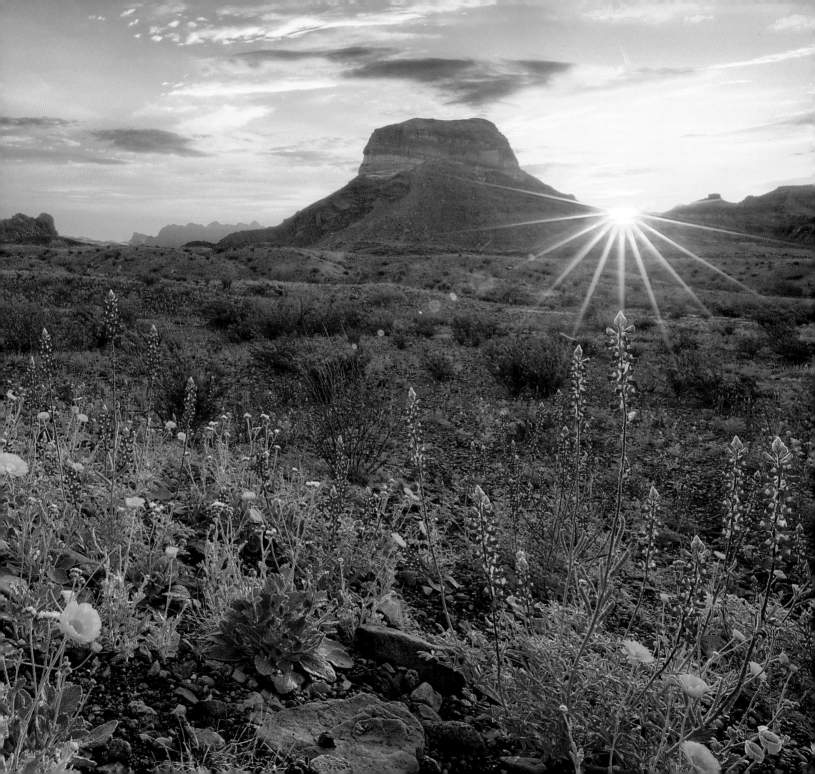

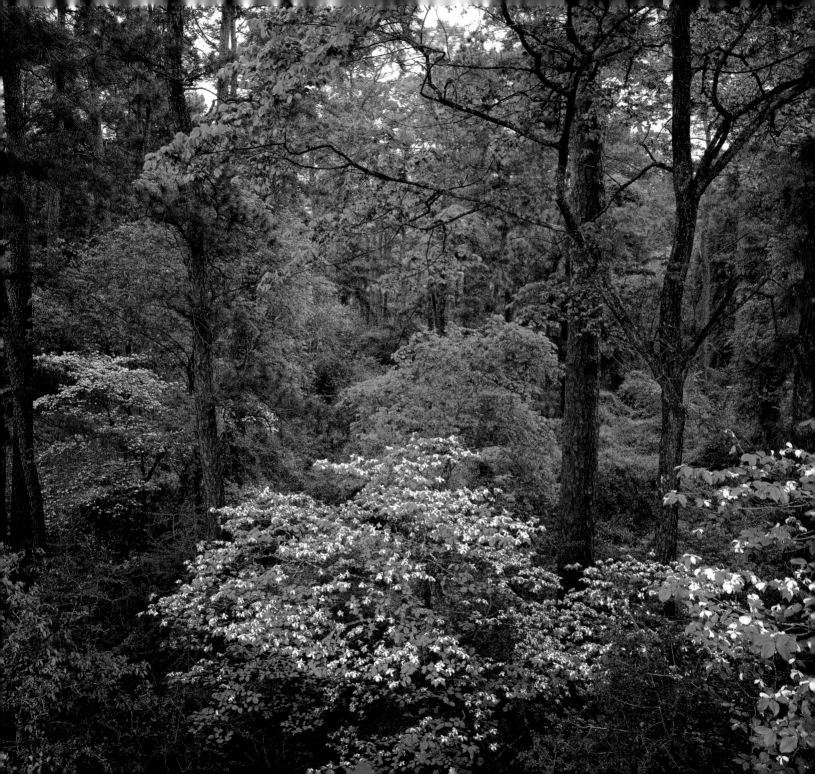

Above: Antelope horns *(Asclepias asperula),* Medina County. Richard Reynolds

Top left: Southern magnolia flower (*Magnolia grandiflora*) Travis County. One of Texas' most beautiful native trees, this evergreen has very fragrant, creamy white flowers up to eight inches across. Richard Reynolds

Bottom left: Dogwood blossoms *(Cornus florida)* in the Piney Woods begin opening in mid-March and will continue blooming for several weeks. Davy Crockett National Forest. Richard Reynolds

Facing page: Dogwood trees grow among the loblolly pines *(Pinus taeda),* Bastrop State Park. Richard Reynolds

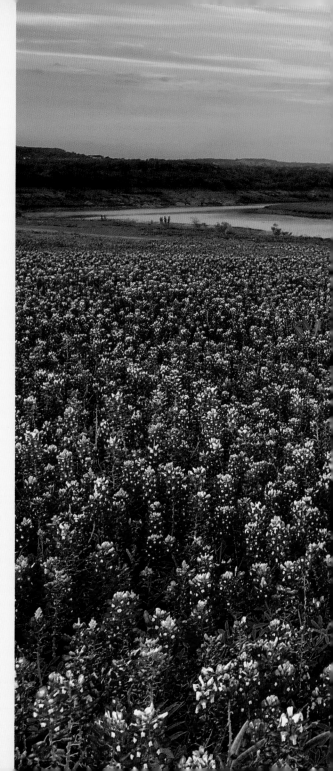

Right: Bluebonnets bloomed in great numbers in spring 2013 at Turkey Bend on the Colorado River. This was one of the rare places wildflowers did grow that spring. This area is normally underwater, but during this dry year, a sea of bluebonnets filled the landscape, bringing the surprise of a beautiful scene to a season of drought. As the morning sun peeked through the clouds, sitting among an unexpected field of bluebonnets seemed a perfect way to start a day in the Hill Country of Texas. Rob Greebon

Below: With a background of Indian blankets, also known as firewheels (*Gaillardia pulchella*), these bluebonnets make for a nice contrast of springtime colors near Dripping Springs outside Austin. Rob Greebon

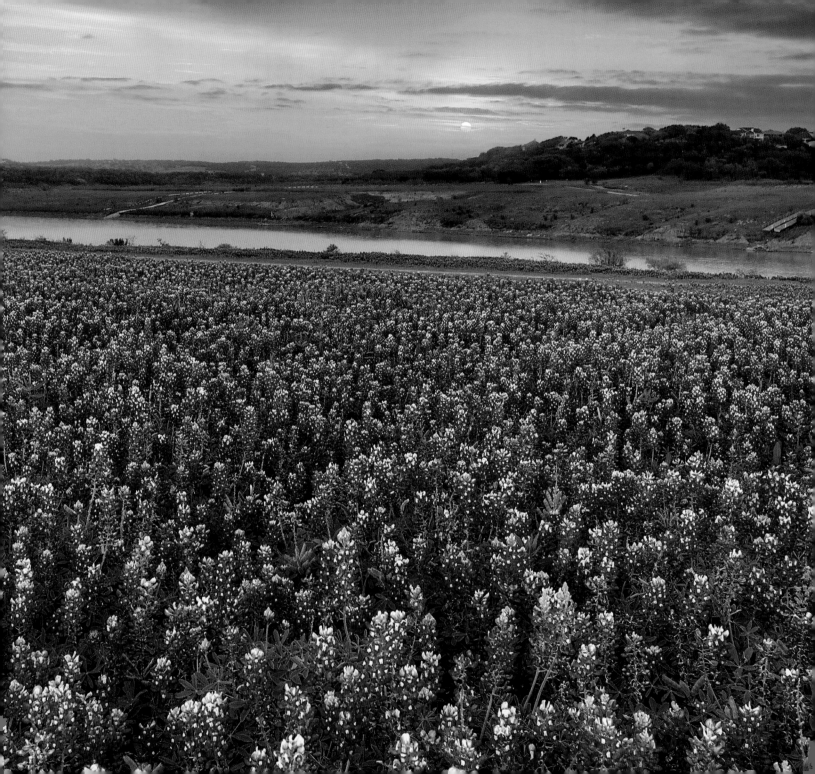

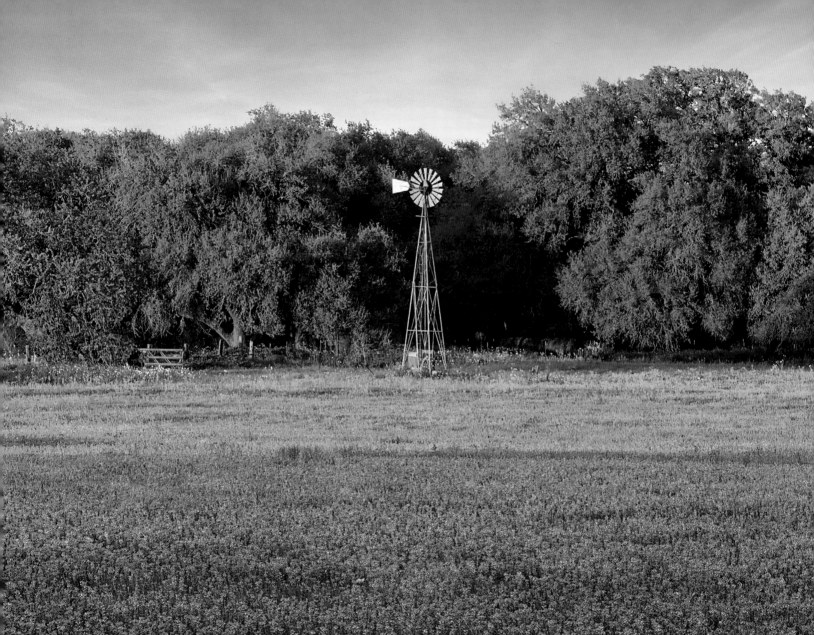

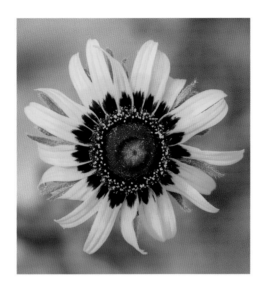

Far left: Near Poteet, a lone windmill rests in a Texas wildflower field colored in the pinks, golds, and blues of an Easter egg—the perfect pastel landscape for Easter weekend. Rob Greebon

Left: Looking down on a yellow coneflower *(Ratibida pinnata)*, the details and texture of this delicate bloom come to life in this photograph shot with a macro lens. Yellow coneflowers enjoy the hot summer long after most Texas wildflowers are gone. Rob Greebon

Left bottom: Pink evening primrose *(Oenothera speciosa)* and prairie verbena *(Glandularia bipinnatifida)*, Medina County. Richard Reynolds

Below: The colorful petals of lantana *(Lantana camara)* create a sprinkling of color after a wind scattered the petals across the ground one summer morning. Rob Greebon

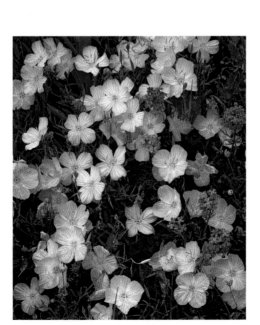

23

Right: This beautiful desert survivor, devil's head cactus *(Echinocactus horizonthalonius),* found in Big Bend National Park, has stiff, pointy spines that are a sharp contrast to its gorgeous magenta flowers. Richard Reynolds

Far right: Plentiful rains in fall and winter create a spring wonderland of blooming cacti, such as this cane cholla *(Cylindropuntia imbricata var. imbricata)* in the lower desert of Big Bend National Park. Richard Reynolds

Below: Lace cactus *(Echinocereus reichenbachii)* and spiderwort *(Tradescantia sp.)* nestle between granite boulders at Enchanted Rock State Natural Area. Richard Reynolds

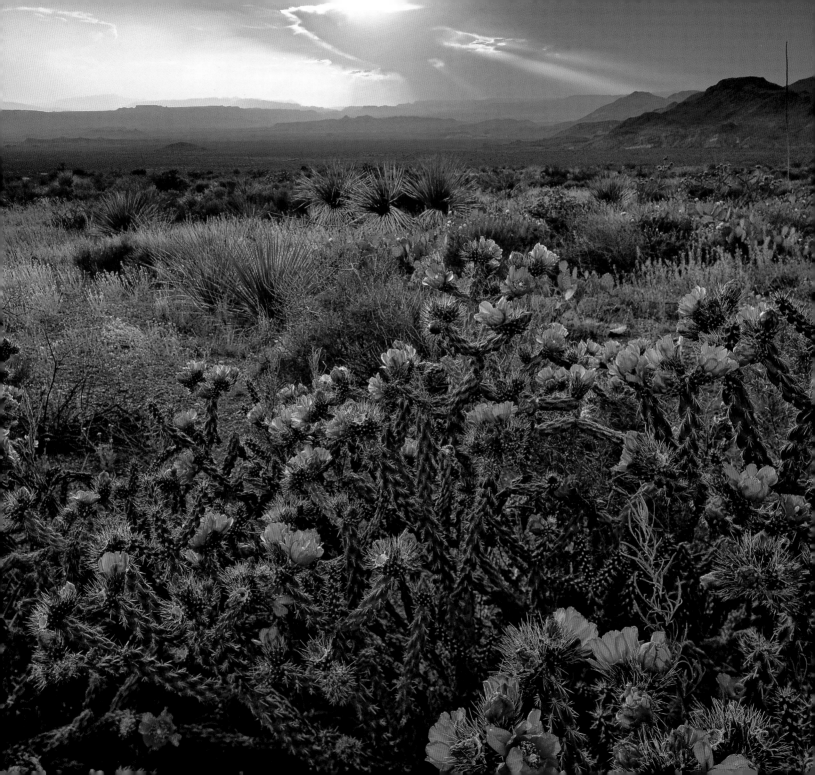

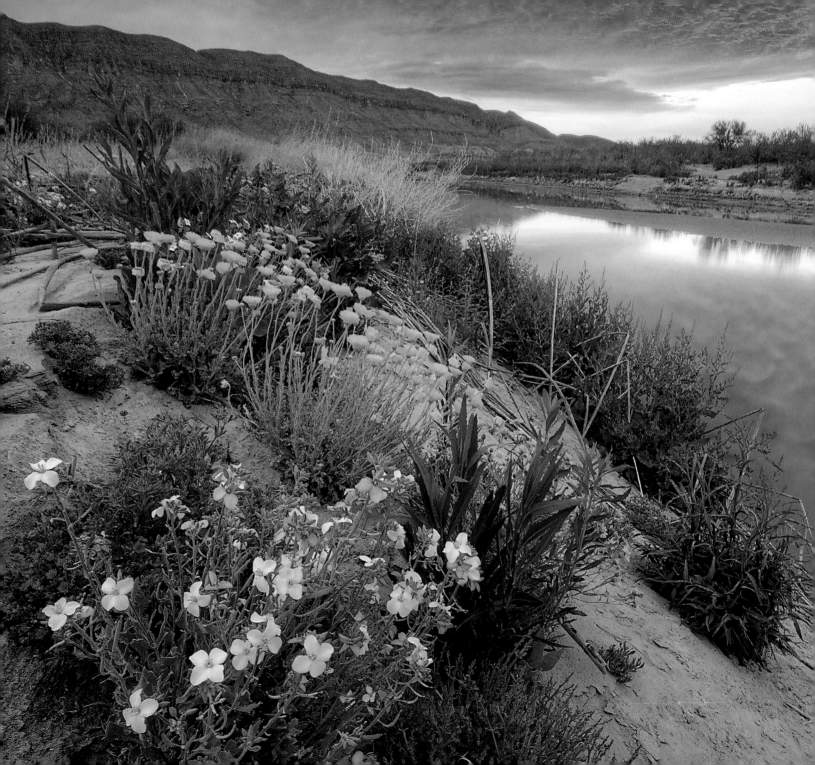

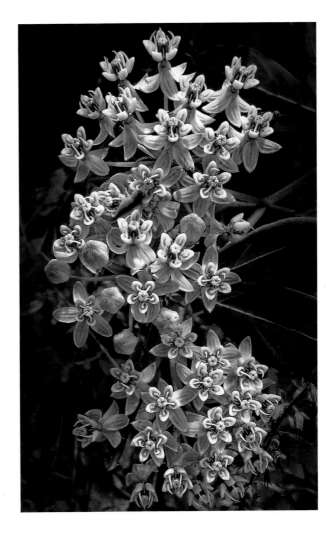

Above: Texas milkweed *(Asclepias texana)*, an essential food source for migrating monarch butterflies, blooms in the woodlands of the Chisos Mountains in Big Bend National Park. Richard Reynolds

Left: Desert marigold *(Baileya multiradiata)* and bicolor fanmustard *(Nerisyrenia camporum)* bring beautiful colors to the dry, cracked banks of the Rio Grande. The waters of this South Texas river, calm and lovely on this spring morning, separate the Lone Star State and Mexico. Rob Greebon

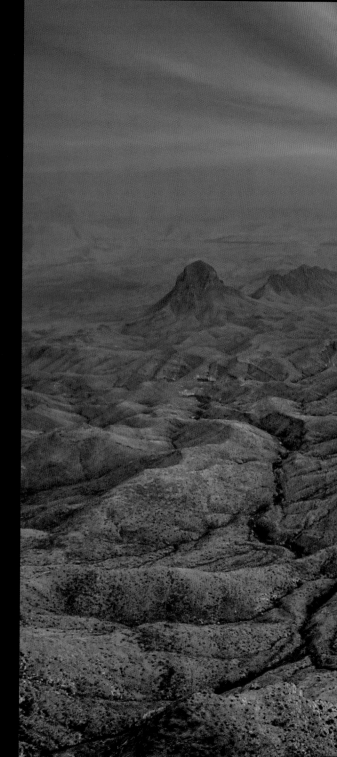

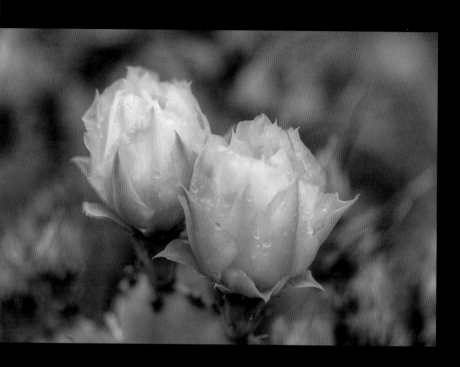

Above: This macro photograph shows the details of a newly bloomed prickly pear cactus flower *(Opuntia sp.)*. Blooming most often in April and May, the prickly pear cacti of Big Bend National Park put on a colorful display of reds, oranges, and golds. But don't get too close—their thorns are not to be trifled with! Rob Greebon

Right: One of the most beautiful hikes in Texas is Big Bend's trek to the South Rim. It is a grunt to reach this location—around thirteen miles round trip—but the views are breathtaking. If you time it right, you can also see some of the wildflowers and cacti in bloom along the way—even on the edge of the rim, as seen here. This prickly pear cacti shows off its delicate blooms as the sun fades in the west over this harsh, but beautiful landscape. Rob Greebon

Previous pages: New Berlin Road lies just east of San Antonio and is famous for spring wildflowers of all colors. On a crisp morning lit with a beautiful sunrise, the panorama included Drummond phlox *(Phlox drummondii)*, Indian paintbrush *(Castilleja indivisa)*, squarebud primroses *(Calylophus berlandieri)*, and sandyland bluebonnets *(Lupinus subcarnosus)*. This rainbow of wildflowers was so stunning, even a police officer stopped by and took notice, saying, "That's a pretty nice pasture of flowers." Rob Greebon

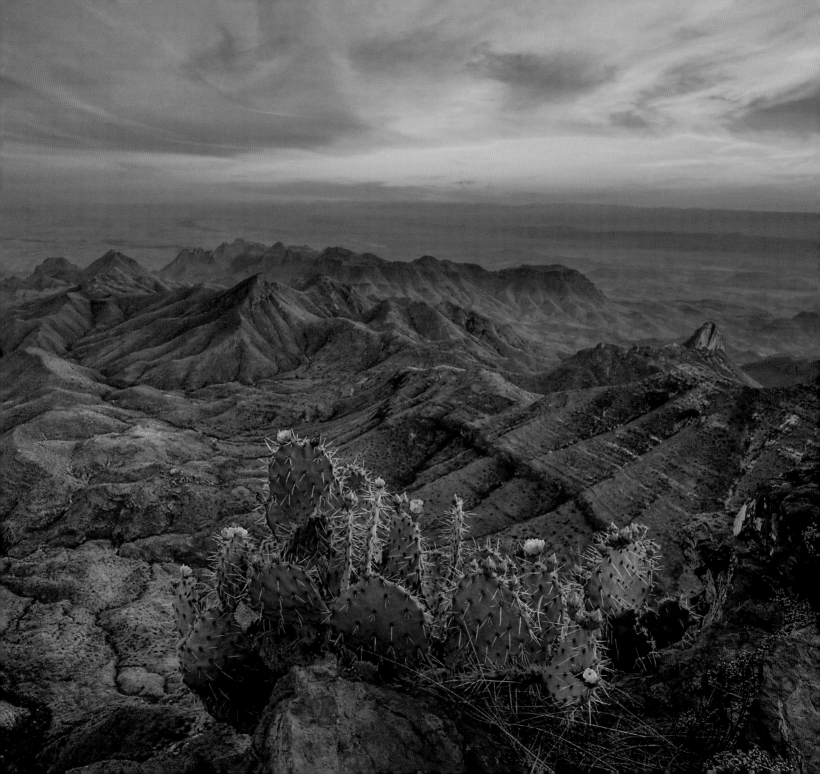

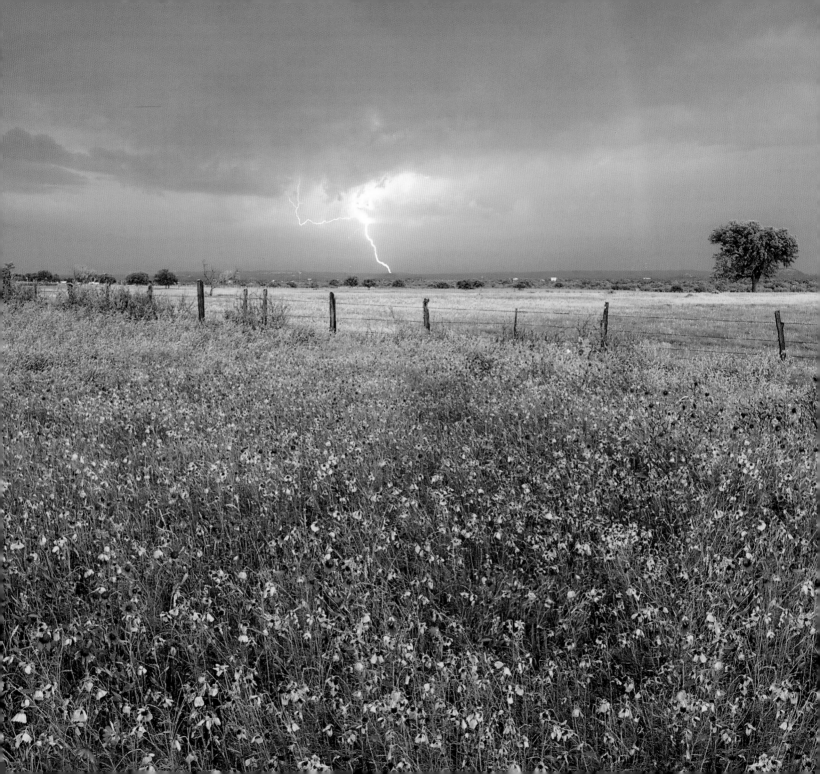

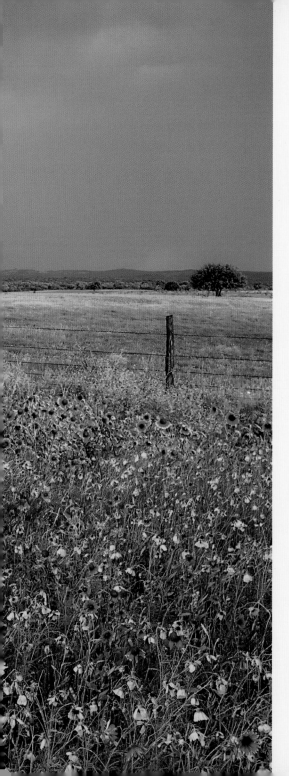

Left: A violent storm had just blown through the northern Hill Country—so severe that I had to pull over because the rain was falling so hard it was difficult to see. Eventually, the storm passed and I found myself on the backside of thunder and lightning with a field of mixed wildflowers before me. With the sun fading in the west and lightning still striking in the east, a rainbow appeared. This was the only time I've seen lightning and a rainbow at the same time, and the reds and golds of Indian blanket *(Gaillardia pulchella)* and goldenwave *(Coreopsis tinctoria)* made the moment even more remarkable.
Rob Greebon

Below: Prickly pear *(Opuntia sp.)*, Drummond phlox *(Phlox drummondii)*, and slender false dragonhead *(Physostegia intermedia)*, Gonzales County. Richard Reynolds

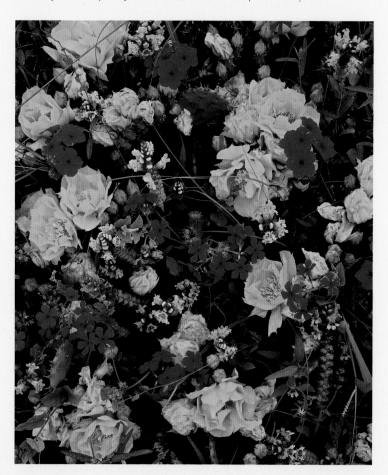

Right: The delicate details of the pink evening primrose (*Oenothera speciosa*) are on full display in a close-up of the "pink ladies" magnificent bloom. Rob Greebon

Far right: Bluebonnets grow in many unusual places. Along these old, out-of-commission railroad tracks, the lack of trains has resulted in a trail of blue winding through the Texas Hill Country. On this particular morning, I had my doubts about capturing a colorful start to the day—but as I was just about to give up, the sky briefly turned pink and purple before fading into late morning colors. Rob Greebon

Below: Near Art, Texas, between Mason and Llano in the Hill Country, this little Methodist church often has a palette of bluebonnets gracing the front acre each spring. For many years, this has been one of my favorite places to photograph a small-town Texas scene. Rob Greebon

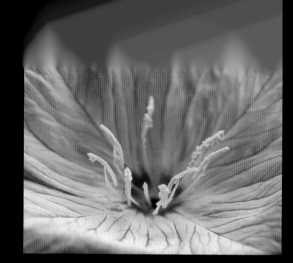

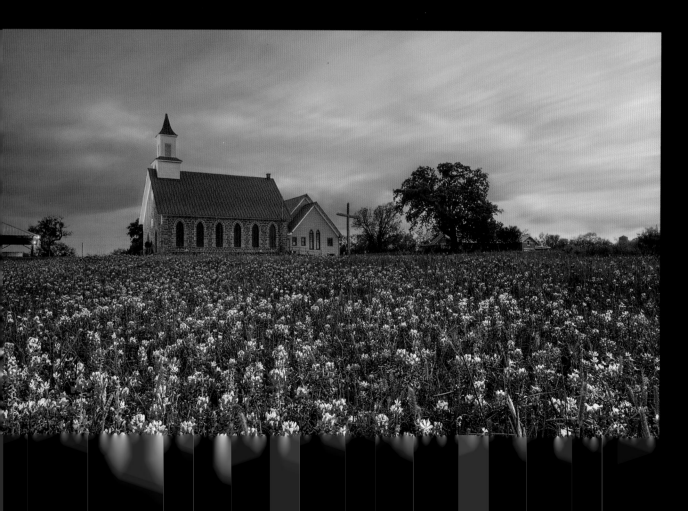

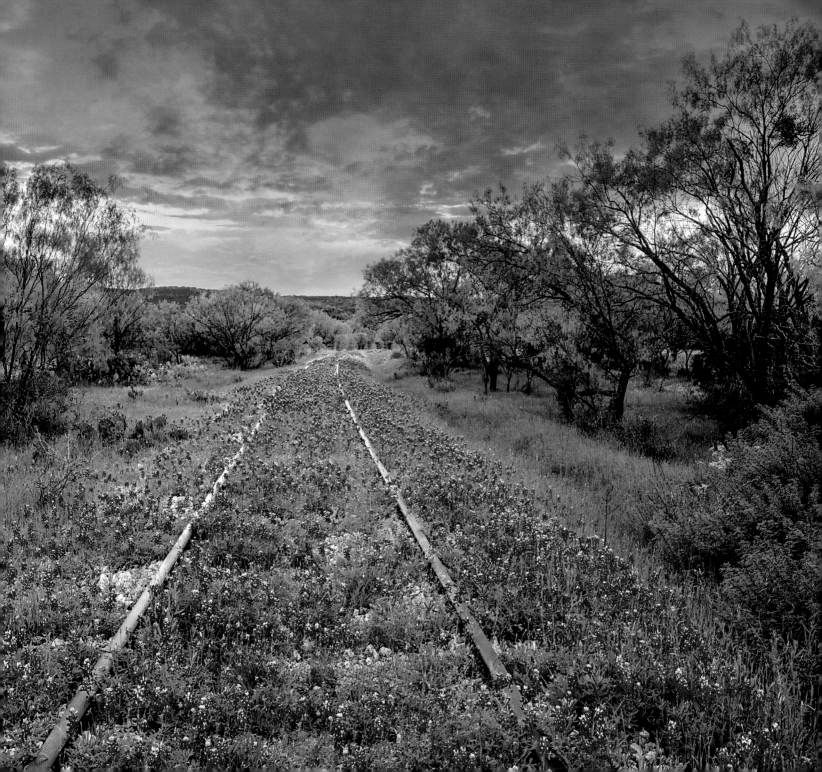

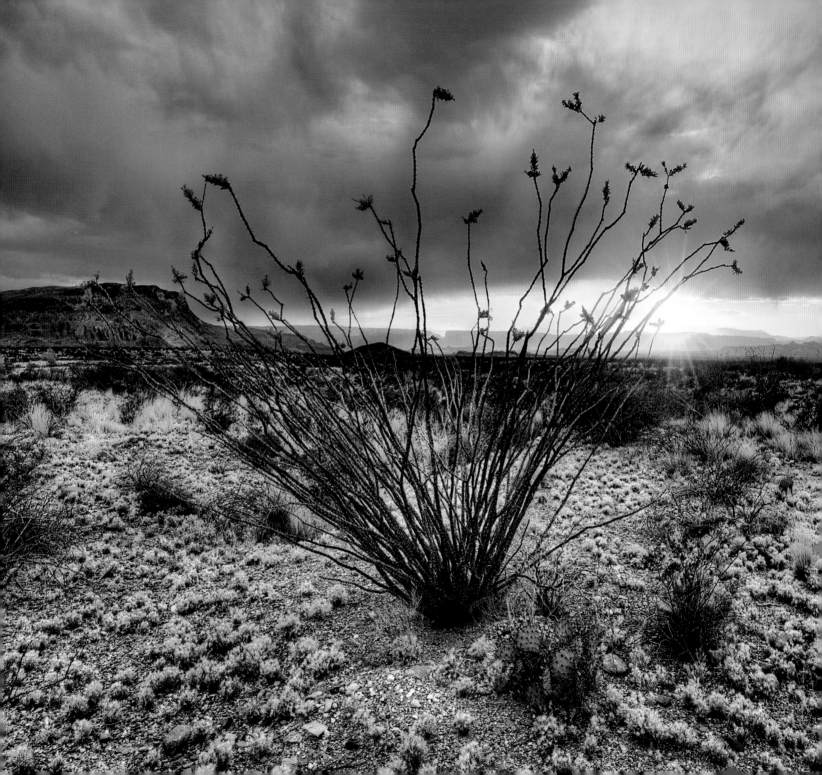

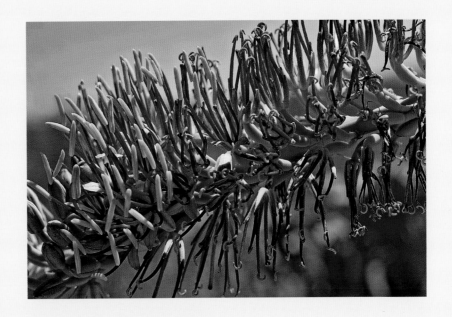

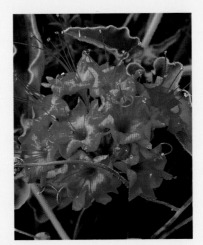

Above: Lechuguilla *(Agave lechuguilla)* flowers, Big Bend National Park. Richard Reynolds

Left: Scarlet muskflower *(Nyctaginia capitata)*, Terrell County. Richard Reynolds

Far left: Rays of sunset peek through an Ocotillo *(Fouquieria splendens)* in the Chihuahuan Desert in Big Bend National Park, and the sky seems to welcome the last light of day. With a storm raging to the south, I could see lightning flashes from the corners of my eyes as I tried to beat the imminent rain. Often these thrilling moments create the best opportunities for capturing the perfect light. Sometimes you just get wet! Rob Greebon

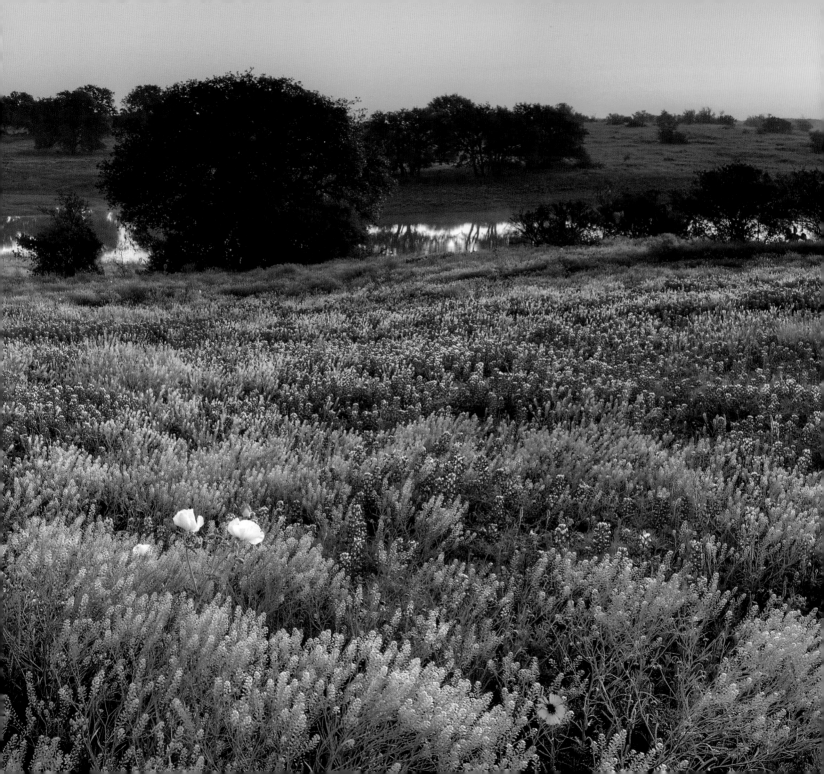

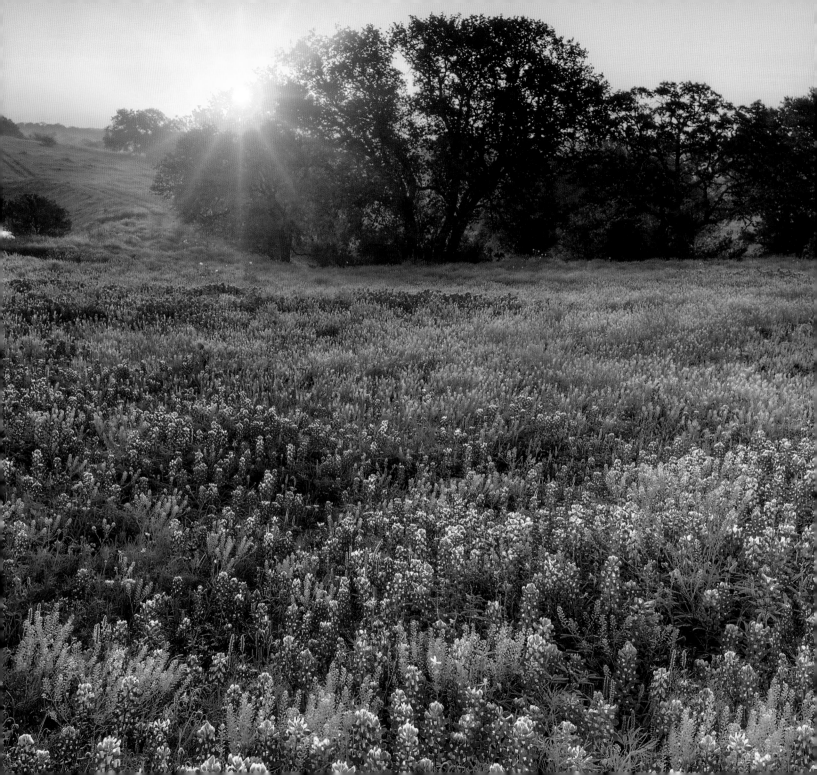

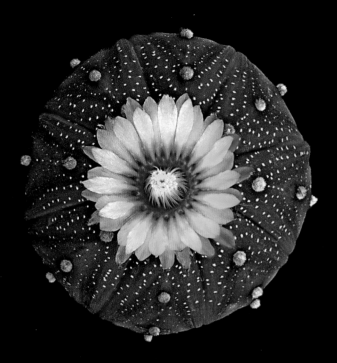

Above: Star cactus *(Astrophytum asterias)*, once abundant but now extremely rare, is limited in Texas to only one 200-acre site in Starr County where there are now fewer than 2,000 individual plants. This unique cactus is also indigenous to the Mexican states of Nuevo Leon and Tamaulipas, and possibly westward to the Sierra Madre. Richard Reynolds

Left: I drive hundreds of miles each spring chasing Texas wildflowers, but sometimes you get lucky closer to home. This field of mixed wildflowers sprang up only twenty minutes from my home in the Hill Country. Primarily firewheels *(Gaillardia pulchella)* and coreopsis *(Coreopsis sp.)*, the reds and yellows welcomed the end of a very pleasant evening. Rob Greebon

Previous pages: I almost always scout out locations before shooting, but on this morning I headed out unprepared and figured I'd find a field of wildflowers easily before sunrise. I drove a long way in the dark, and as sunrise drew near, I found myself driving quickly down dirt roads in the Hill Country in search of anything to shoot. Fortunately, with only minutes to spare, I found this field of stiff greenthread *(Thelesperma filifolium)*, white pricklypoppy *(Argemone albiflora var. texana)*, and bluebonnets leading down to a quiet pond as the sun peeked through the distant trees. Rob Greebon

41

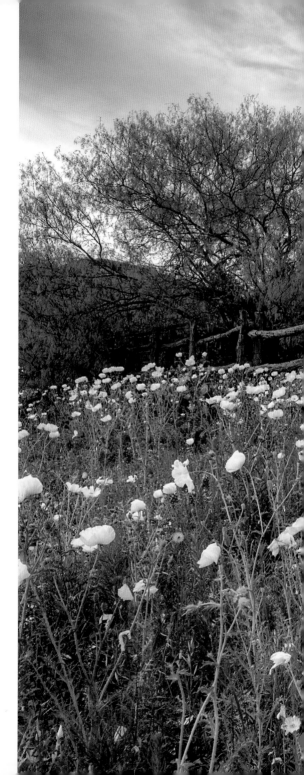

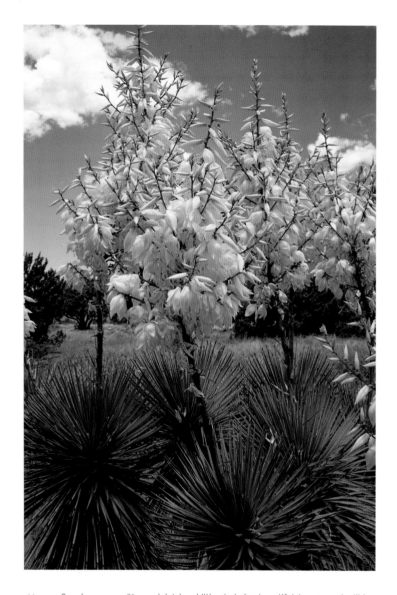

Above: Soaptree yucca *(Yucca elata)*, in addition to being beautiful, has several edible parts, including its creamy white flowers. Jeff Davis County. Richard Reynolds

Right: White pricklypoppies *(Argemone albiflora var. texana)* brighten this field of wildflowers along an old wooden fence in the Texas Hill Country. This off-the-beaten-path country road between Fredericksburg and Llano seems to hold a new surprise at every bend. Rob Greebon

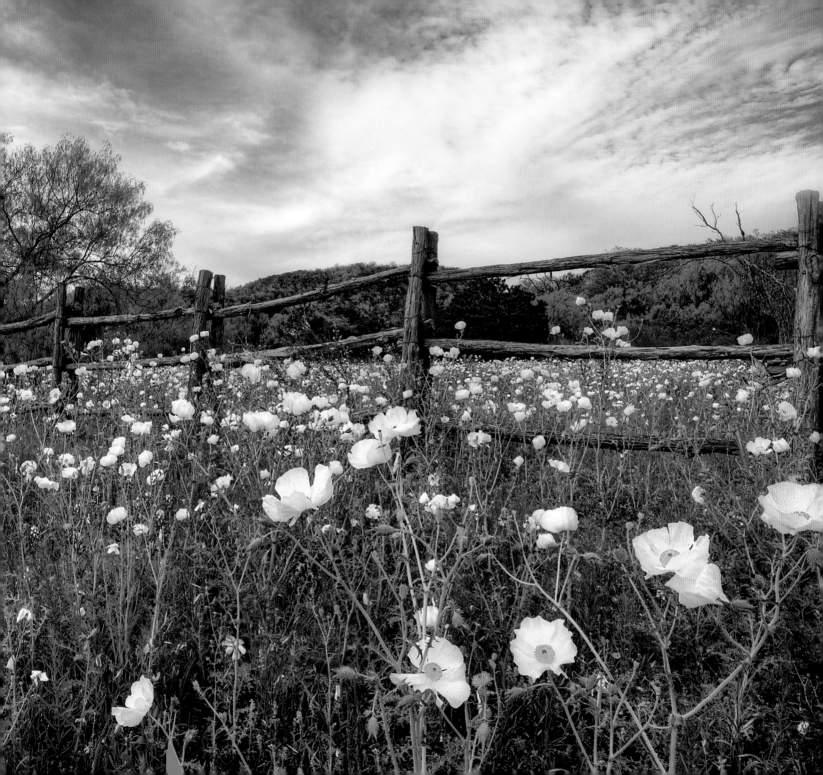

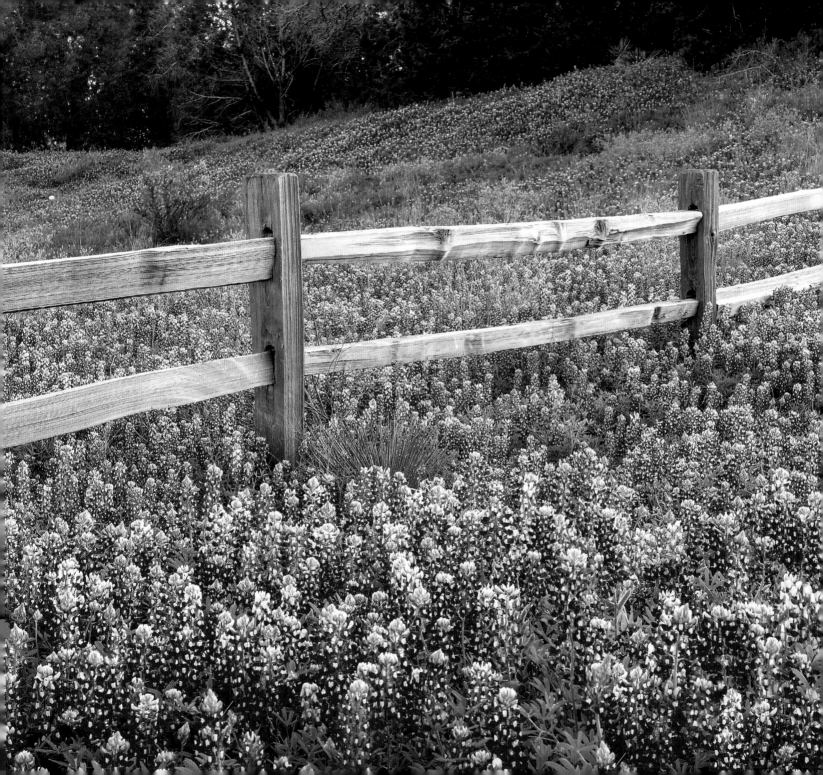

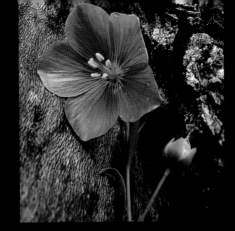

Rim in Big Bend National Park and found at least fifteen flowering plants in the shade of Boot Canyon. Among them was this wild blue flax *(Linum lewisii).* Richard Reynolds

Far left: A sea of blue stretches all the way to the trees on a late March evening. I've returned to this location near Llano several times over the years. Found along Highway 29 in the Hill Country, this old wooden fence is often surrounded by bluebonnets. Rob Greebon

Below: Along a backroad near Marble Falls, these horses were enjoying a cool April morning in a field of bluebonnets. The beautiful creatures trotted to the barbed-wire fence that separated us, most likely thinking I'd have a snack for them. When I had nothing to offer except a smile and a rub on the snout, they went back to their grazing. Rob Greebon

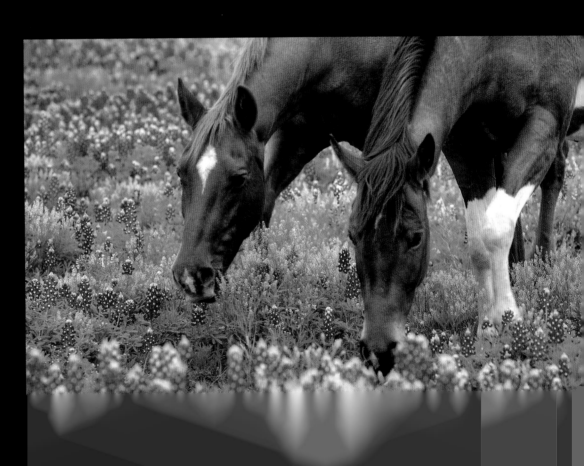

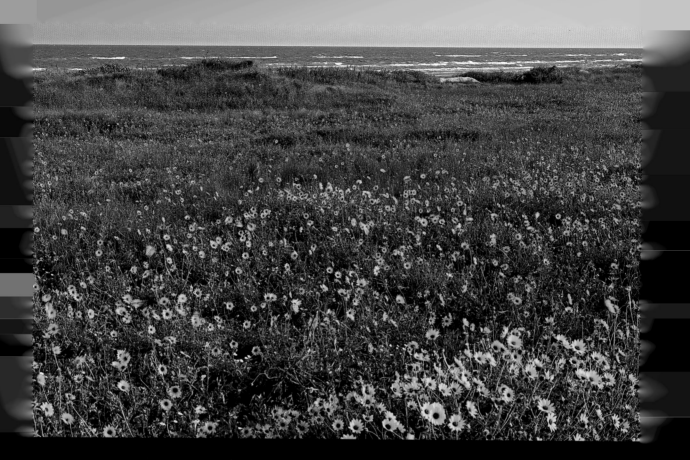

Above: Sunflowers *(Helianthus sp.)* flourish in the sand dunes of Galveston Island.
Richard Reynolds

Right: In the sunflower family, the brown-eyed susan *(Rudbeckia hirta),* also called
black-eyed susan, has yellow petals with brown or black cone centers. These hardy
wildflowers grow in a wide variety of conditions, often found along highways, ditches,
and fields, from the open woods of East Texas to the sandy soils of South Texas. The
Cherokee used parts of this flower for medicinal purposes. Rob Greebon

Facing page: Sunrise finds railroad vine flowers *(Ipomoea pes-caprae)* already
blooming on a warm June morning at Padre Island National Seashore.

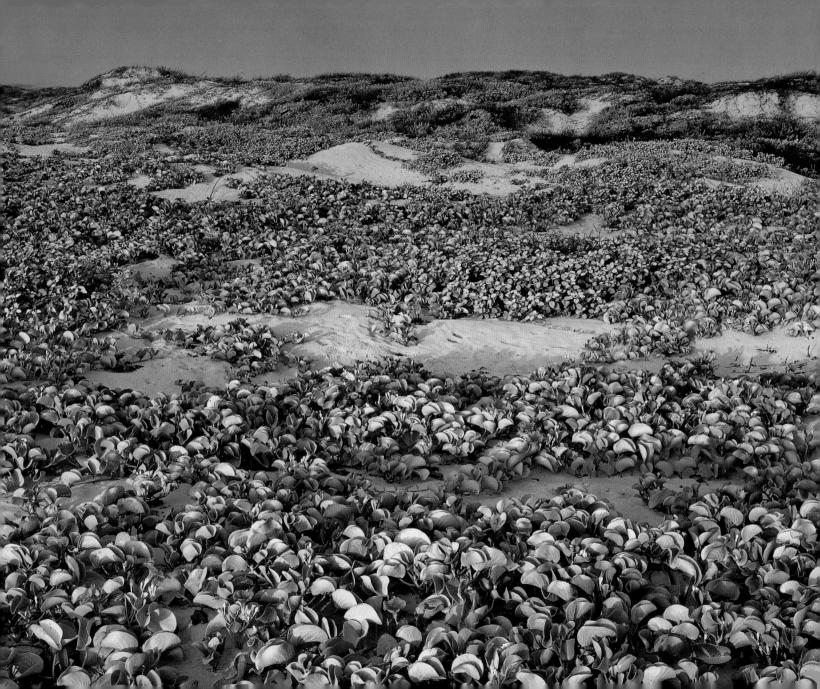

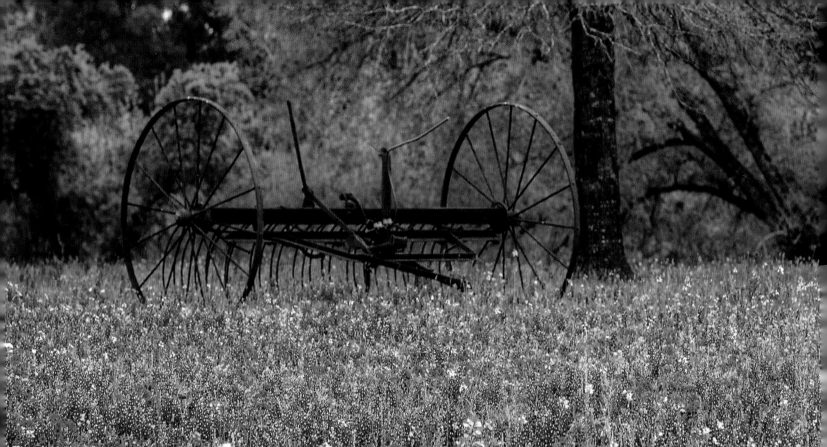

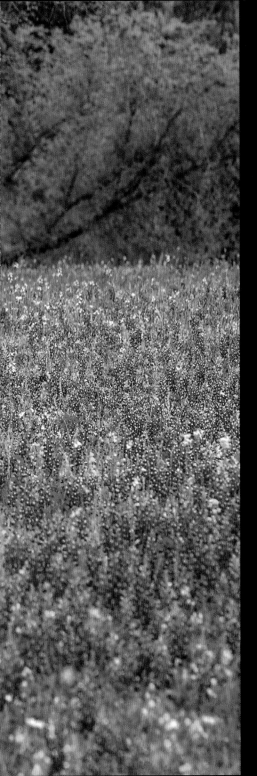

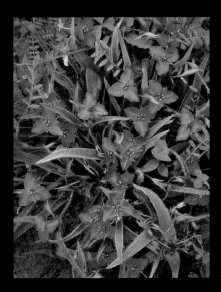

Left: Spiderwort *(Tradescantia sp.)* rises from the sandy soils of Buescher State Park, four years after a devastating fire burned as much as 95 percent of the pine forest. Richard Reynolds

Far left: While driving through rural countryside near Luling, I spotted this old wagon in a field of mixed wildflowers primarily made up of bluebonnets and Drummond phlox *(Phlox drummondii)*. I made a U-turn in the road and took several photographs of this old farm implement, thinking the scene perfectly represented small-town Texas. Rob Greebon

Below: Sometimes a single flower really captures my attention. While photographing a field of bluebonnets in the Texas Hill Country, this lone Indian paintbrush *(Castilleja indivisa)* stood alone, catching my eye as its red petals shone brightly among the sea of blue. Rob Greebon

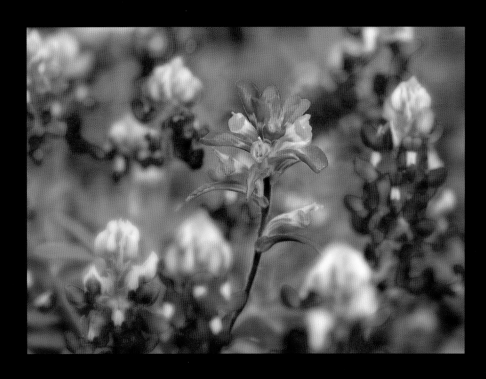

Right: Desert savior (*Echeveria strictiflora*), a hardy succulent, blooms in Boot Canyon in the Chisos Mountains of Big Bend National Park. The flower stalks of this specimen remind me of a pair of seahorses. Richard Reynolds

Far right: While out chasing bluebonnets, desert marigolds (*Baileya multiradiata*), and other wildflowers on East River Road in Big Bend National Park, I was treated to this spectacular light show as the sun set over the Chisos Mountains. I was on this dirt road for nearly two hours and never saw another person—my idea of a wonderful evening. Rob Greebon

Below: The three varieties of prairie paint brush (*Castilleja purpurea*) have bracts ranging from yellow to orange to red to purple, with many shades in between. They are the most abundant in the northern and northwestern reaches of the Texas Hill Country. Richard Reynolds

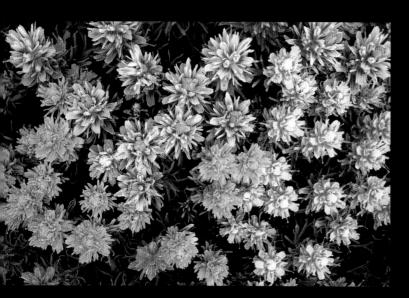

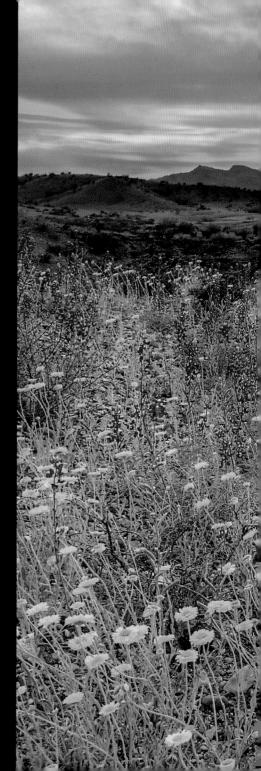

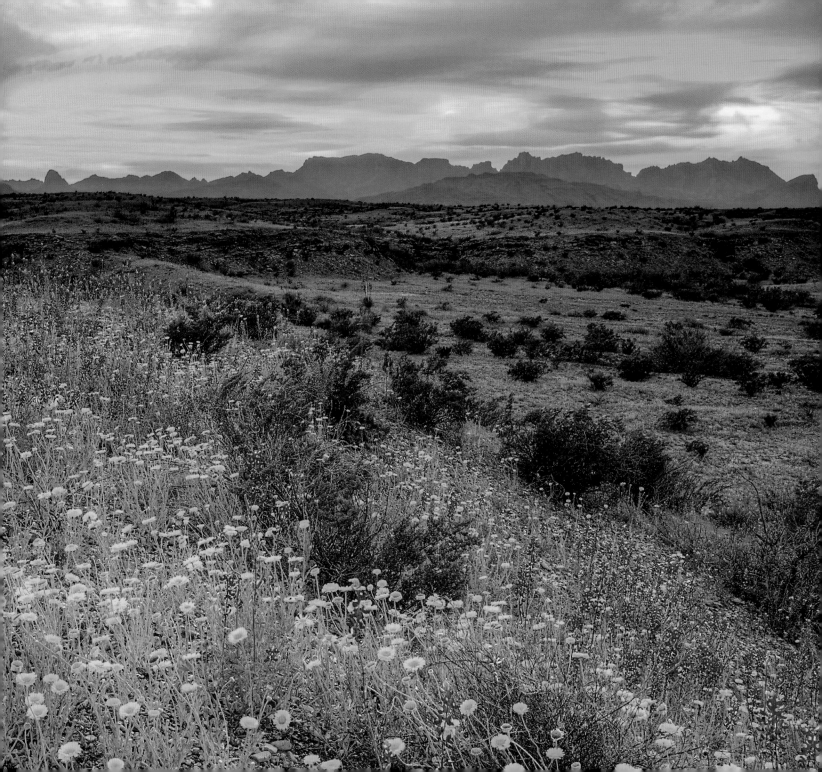

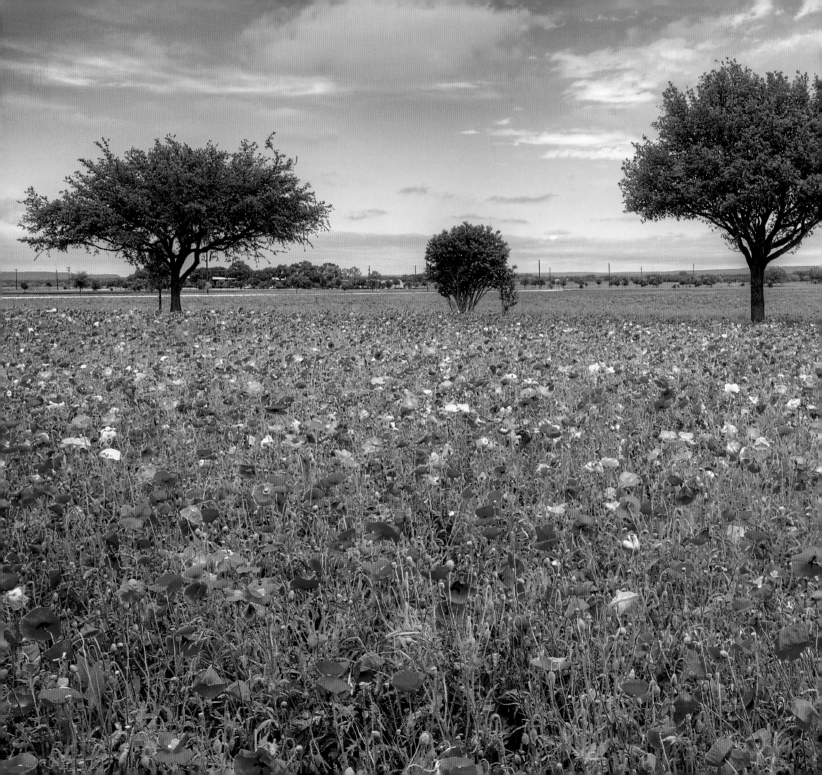

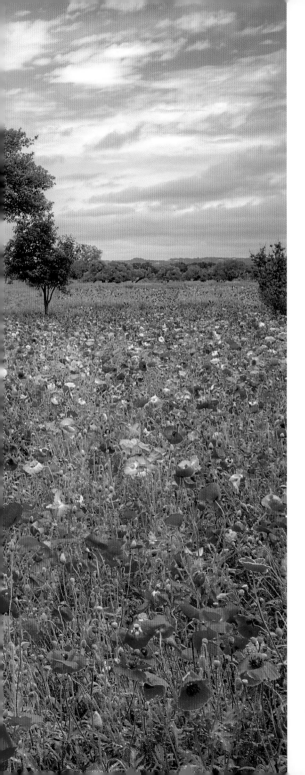

Left: This patch of corn poppies *(Papaver rhoeas)* at Wildseed Farms in Fredericksburg are in full bloom as clouds begin to break up after an overcast spring day. Rob Greebon

Below: On a quiet morning near Dripping Springs in the Hill Country, this purple coneflower *(Echinacea angustifolia)* enjoys the soft light of a spring sunrise. Purple coneflowers generally bloom from April to late June. This little Texas wildflower lasted into late July thanks to a wet and cool spring and early summer. Rob Greebon

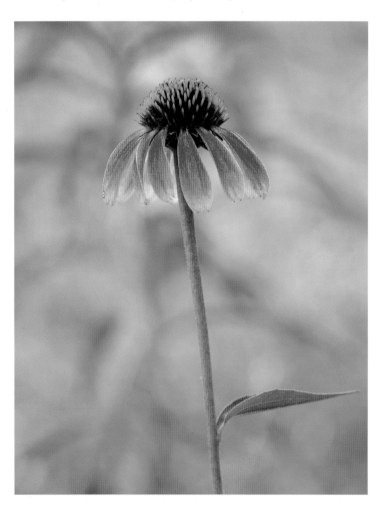

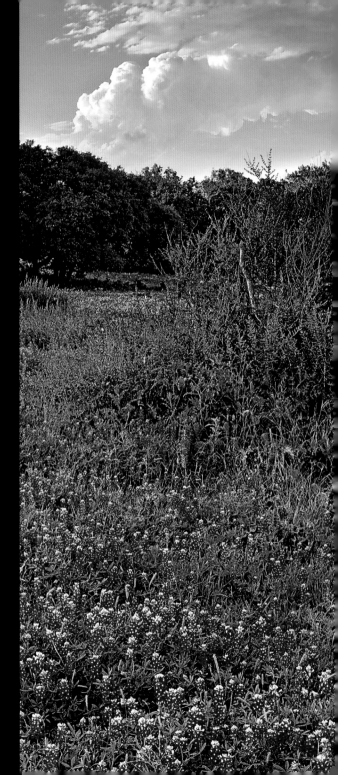

Right: It was nearing sunset and I was about to head home after a productive day of wildflower photography in the Hill Country. On a whim, I took a detour off the main highway onto a little-used farm-to-market road near Stone Mountain. Sometimes, hunches work out in your favor. This scene of bluebonnets and white pricklypoppies *(Argemone albiflora var. texana)* in Blanco County awaited me just as the setting sun gilded the cumulus clouds on the horizon to make an unforgettable panorama. Richard Reynolds

Below: Drummond phlox *(Phlox drummondii)*, baby blue eyes *(Nemophila menziesii)*, spiderwort *(Tradescantia sp.)*, and chickweed *(Stellaria sp.)*, Gonzales County. Richard Reynolds

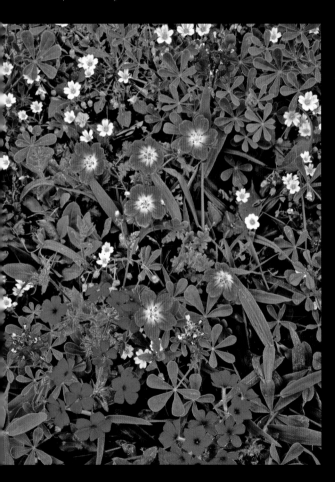

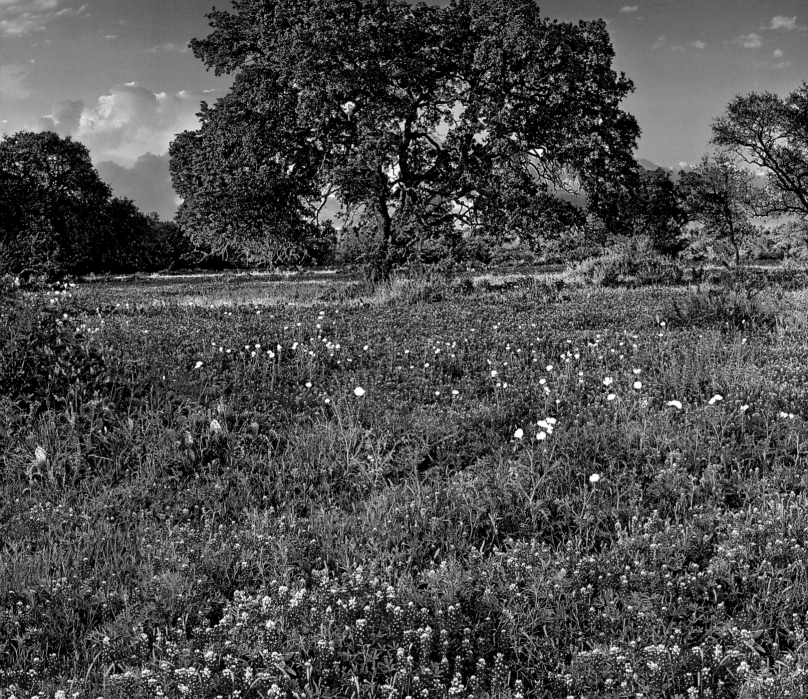

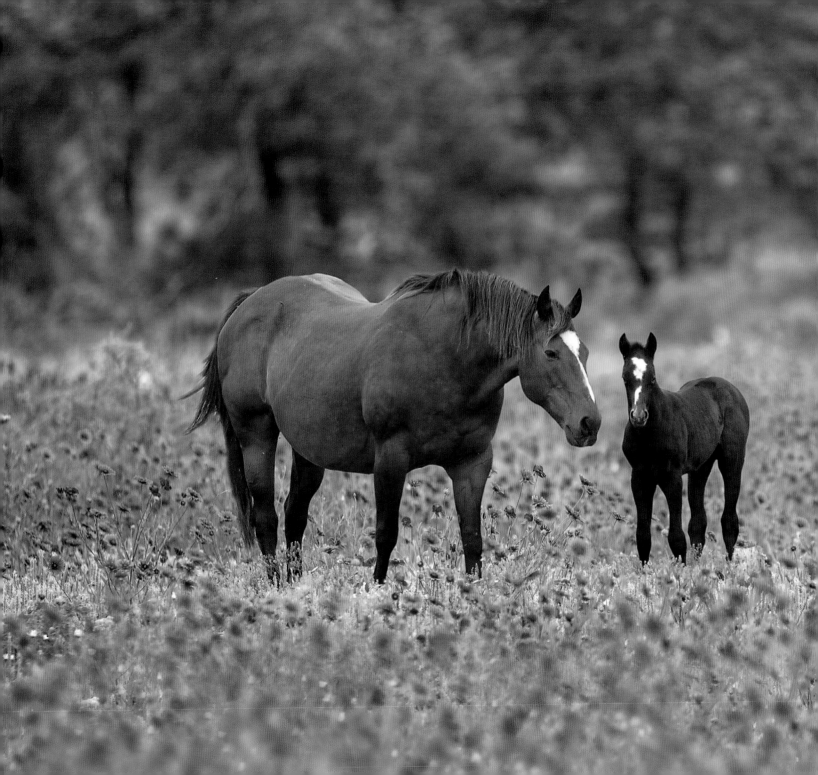

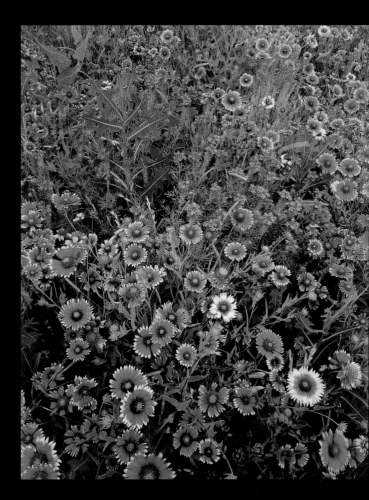

Above: Indian blanket *(Gaillardia pulchella)* and prairie verbena *(Glandularia bipinnatifida)*, Real County. Richard Reynolds

Left: Many of my favorite wildflower images are taken from dirt roads off the beaten path, some of which I don't even know if I could find again. This is one of those photographs. I was driving around with my daughter and we came across this field of Indian blankets in the northern part of the Hill Country. She loves horses, so it was only fitting that we stopped to photograph this scene of a mare and her foal. Rob Greebon

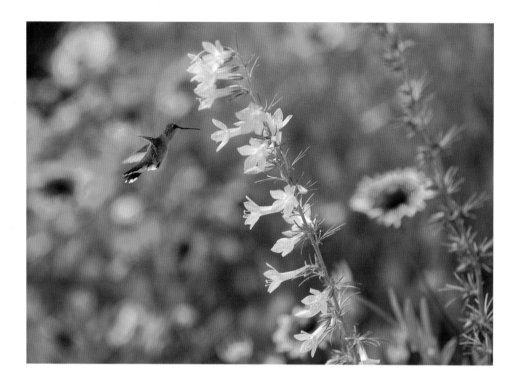

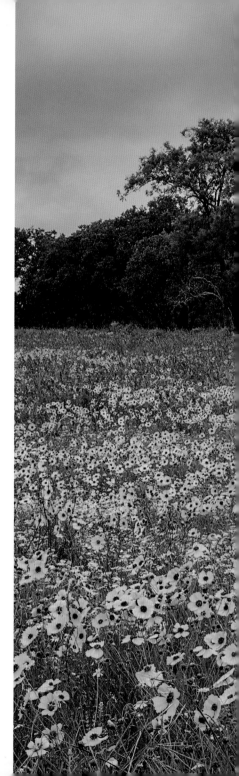

Above: Hummingbirds love these yellow standing cypress *(Ipomopsis rubra)*. One of my favorite things to do in the spring is set up my tripod and wait for hummingbirds. Here I captured a fragile flyer as it sought the sweet nectar inside these tubular flowers. Rob Greebon

Right: This vetch *(Vicia sp.)* found in Hardin County is beautiful, but it is an invasive species. Richard Reynolds

Far right: I was returning from a trip to the Guadalupe Mountains one day in late spring, and although tired from my long journey, I couldn't help but pull over and take photographs of this longhorn mother and her calf in a field of stiff green-thread *(Thelesperma filifolium)* and mealy blue sage *(Salvia farinacea)*. The longhorns enjoying the afternoon gave me no notice as I photographed the scene with a telephoto lens. I've learned by experience I'd rather stop and take the shot, rather than wish later that I'd stopped! Rob Greebon

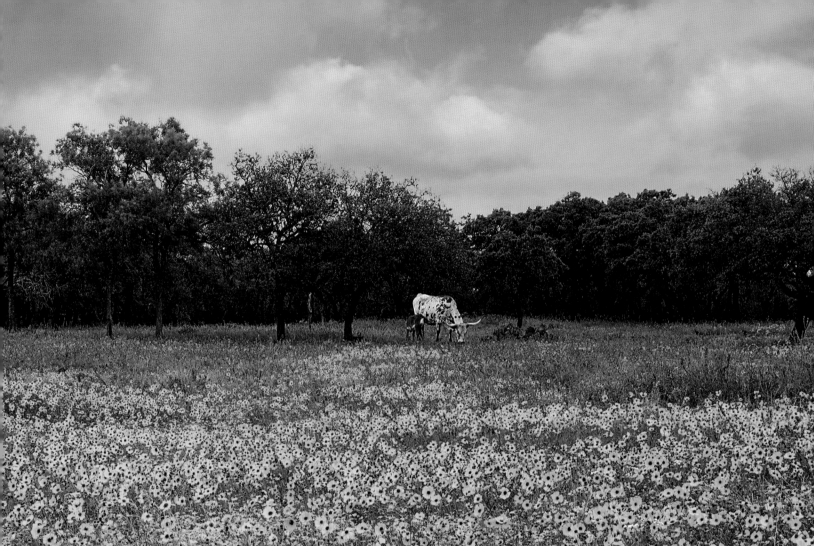

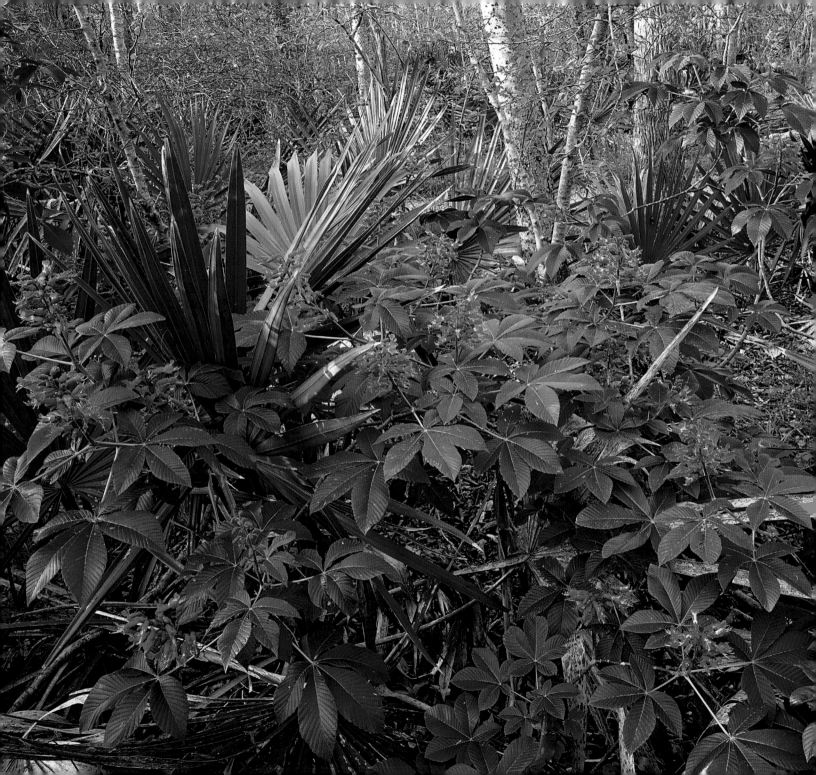

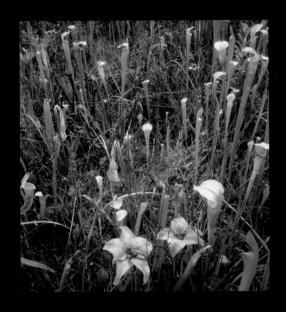

Facing page: Red buckeye *(Aesculus pavia L. var. pavia)* blooms among the dwarf palmettos in Palmetto State Park. Richard Reynolds

Left: Pitcher plants *(Sarracenia alata)*, one of four carnivorous plants in Big Thicket National Preserve, rise from a bog in the southeast Texas sanctuary. Richard Reynolds

Left bottom: Giant blue iris *(Iris giganticaerulea)* graces a roadside in Bowie County. Richard Reynolds

Below: Wild azaleas *(Rhododendron canescens)* in full bloom in Newton County along the Texas-Louisiana border. Richard Reynolds

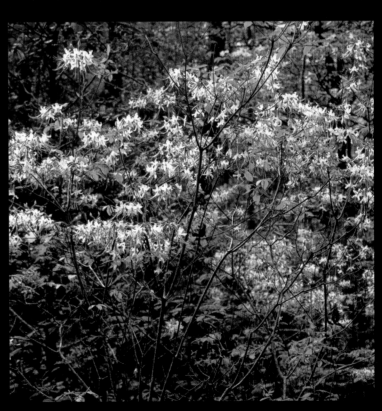

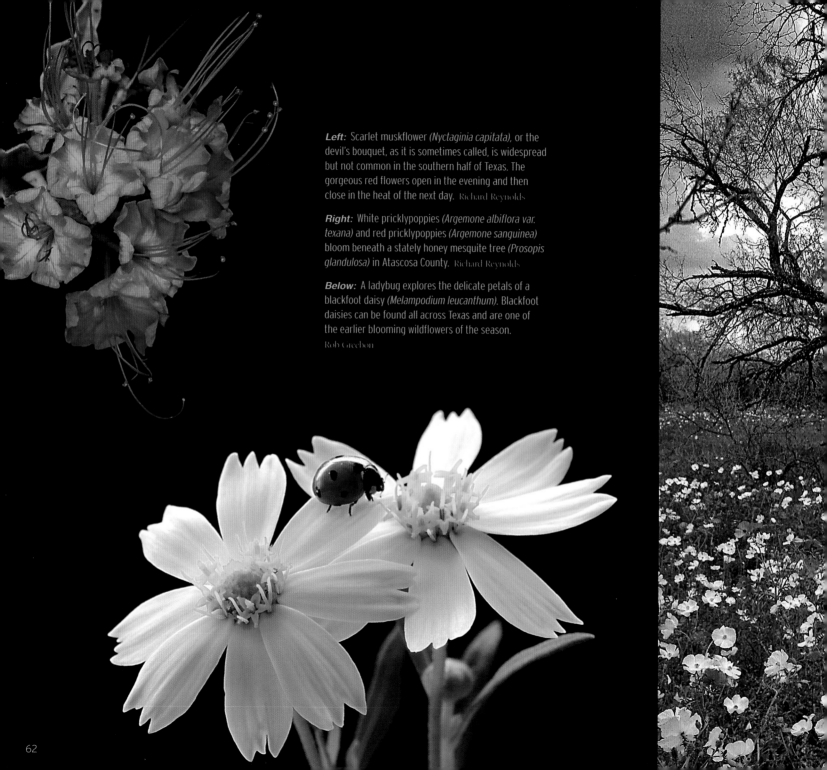

Left: Scarlet muskflower *(Nyctaginia capitata),* or the devil's bouquet, as it is sometimes called, is widespread but not common in the southern half of Texas. The gorgeous red flowers open in the evening and then close in the heat of the next day. Richard Reynolds

Right: White pricklypoppies *(Argemone albiflora var. texana)* and red pricklypoppies *(Argemone sanguinea)* bloom beneath a stately honey mesquite tree *(Prosopis glandulosa)* in Atascosa County. Richard Reynolds

Below: A ladybug explores the delicate petals of a blackfoot daisy *(Melampodium leucanthum).* Blackfoot daisies can be found all across Texas and are one of the earlier blooming wildflowers of the season. Rob Greebon

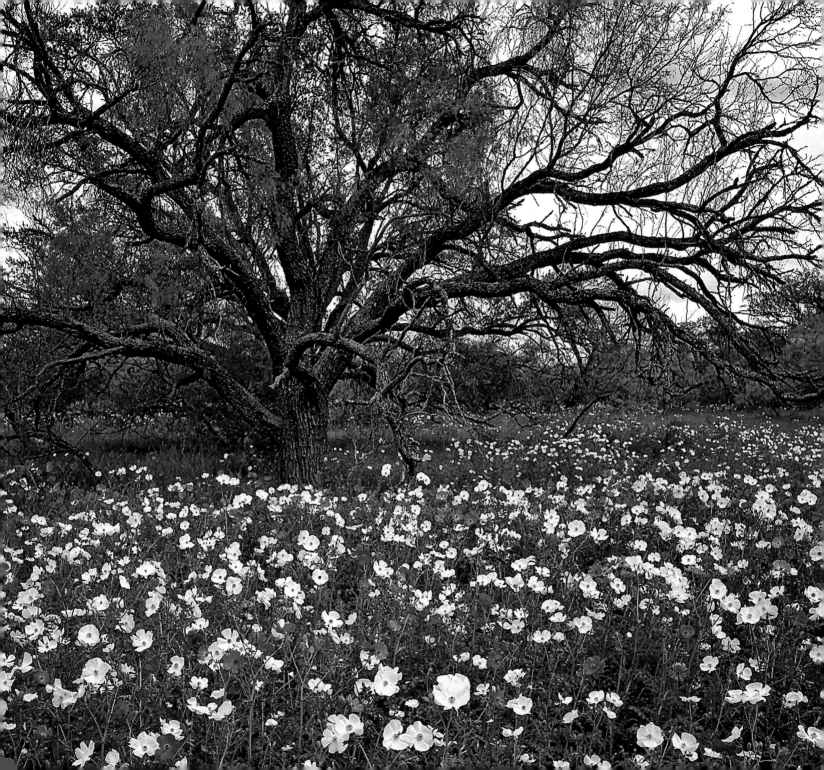

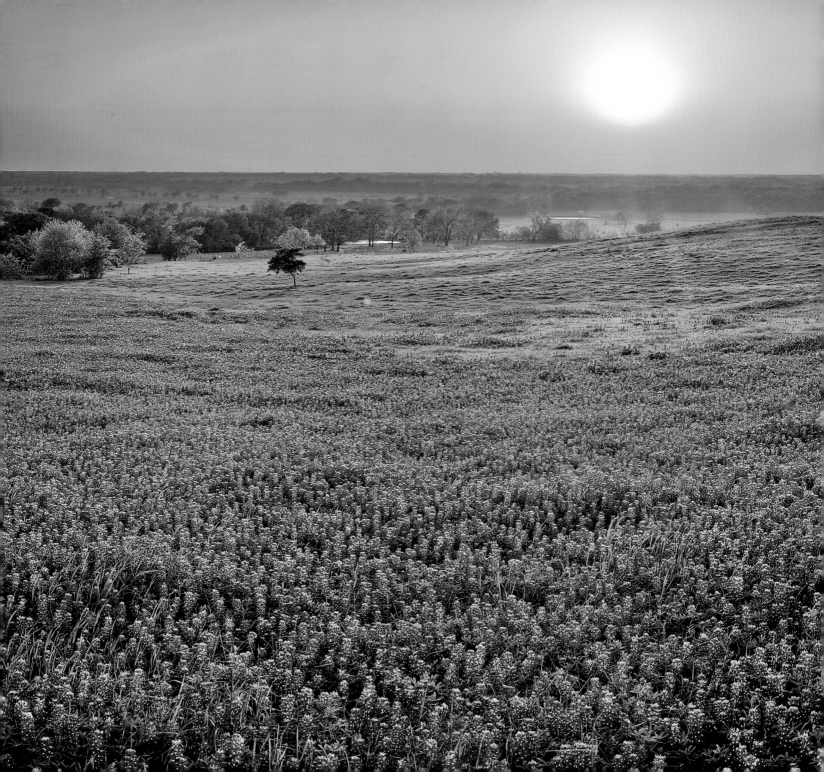

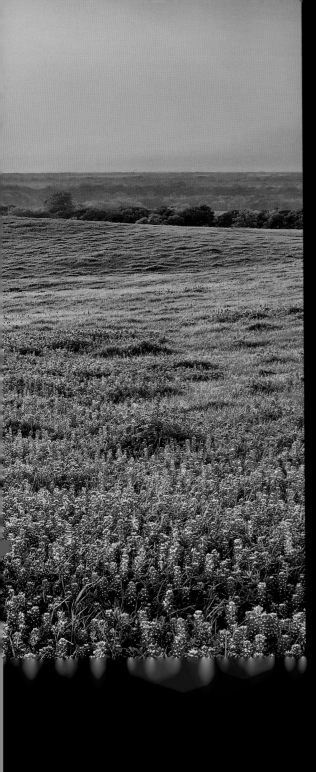

Left: The bluebonnets around Ennis are legendary, and this image shows why. Driving the Bluebonnet Trails around this north-central town in early April reveals field after field of Texas's state flower. Richard Reynolds

Below: Like a painter's palette, this Texas wildflower image, taken in the Hill Country near Llano, is a sea of color, from bluebonnets to firewheels to coreopsis. I spent an entire evening here photographing these wildflowers. Rob Greebon

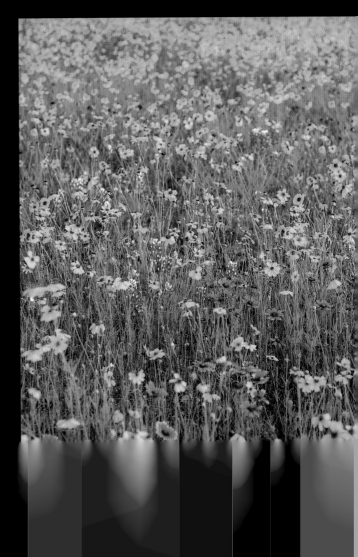

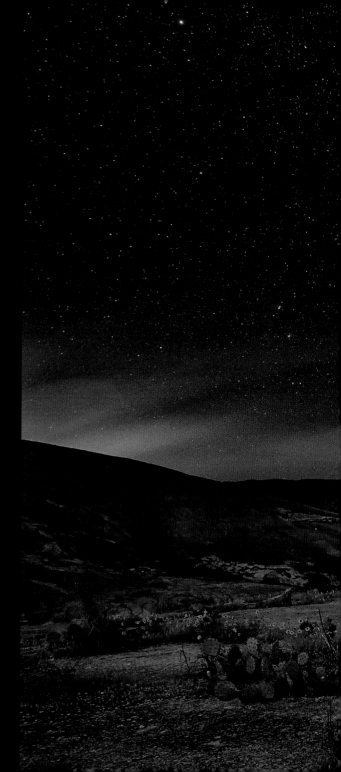

t: Golden wildflowers called coreopsis *(Coreopsis tinctoria)* spread across the granite
of Little Rock, with its more famous ancient neighbor, Enchanted Rock, nearby.
ead, the Milky Way moves quietly across the night sky. Enchanted Rock State Natural
has been designated an International Dark Sky Park, known as one of the best public
 for stargazing in central Texas due to its remote, rural sky that is still dark enough
 the Milky Way. Nighttime lighting in the park is limited to preserve darkness, so the
 walk to this viewpoint is interesting, as the trail always looks different at night—
night like this makes the trek worth the effort. I made this composition image from
al individual photographs taken that night—the foreground shot a little after sunset,
lky Way taken as long exposures (approximately two and a half minutes) well into the
—then I blended the images to show this amazing view of our universe. Rob Greebon

w: The triangle cactus *(Acanthocereus tetragonus)* has a large, white, fragrant bloom
pens at night in mid to late summer, usually an hour or so after sunset. This unruly
grows stems up to twenty feet long that rely on other plants in the thornscrub
onment for their support. Good examples can be found in the southernmost
al plains, especially between Brownsville and Boca Chica. Richard Reynolds

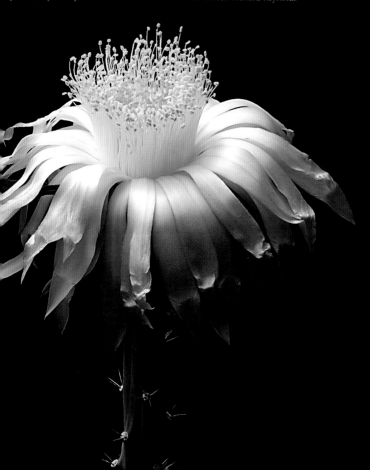

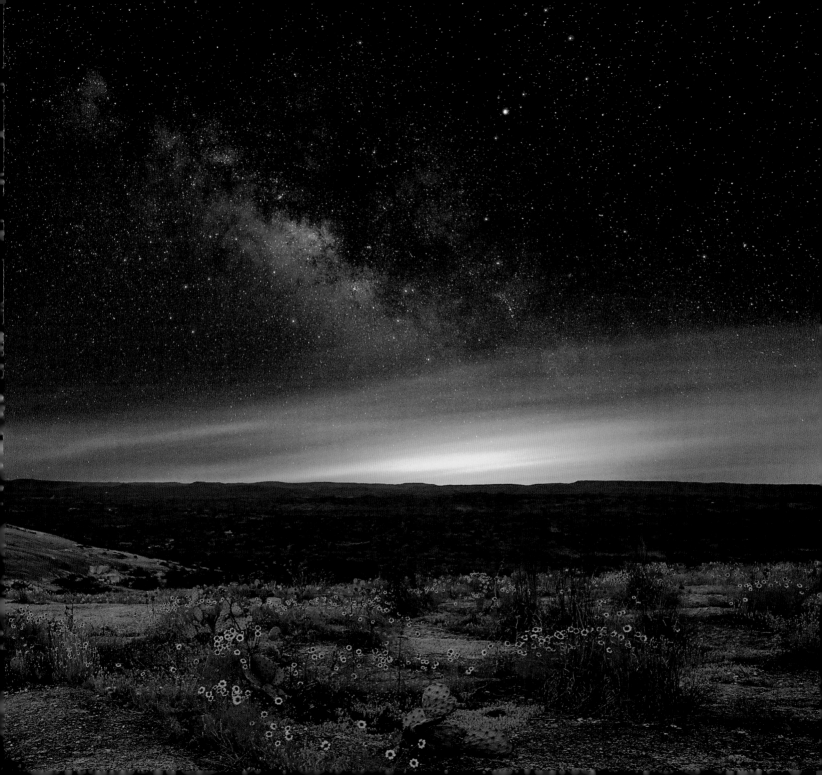

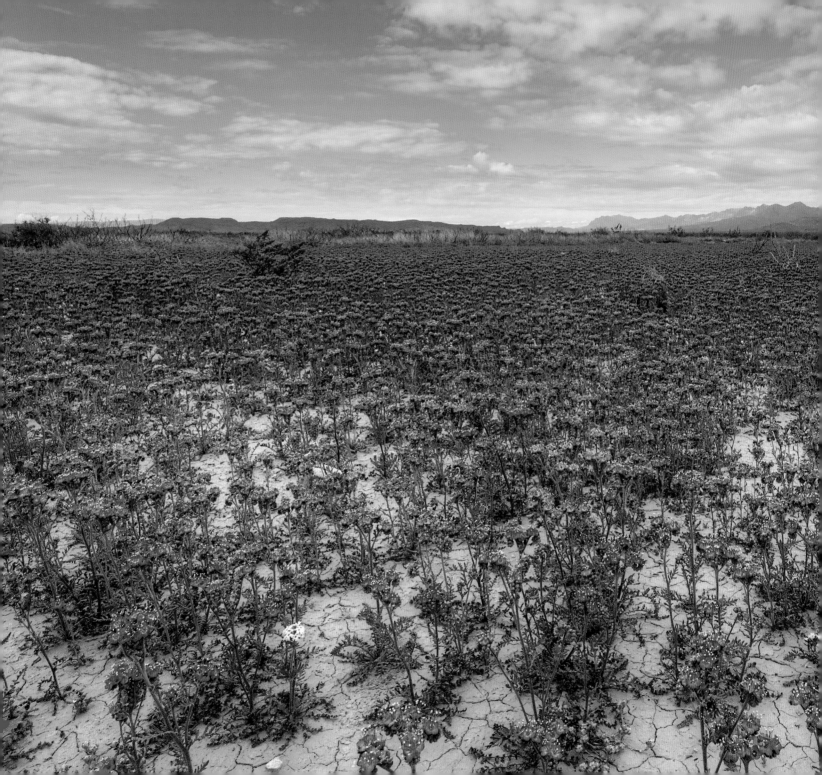

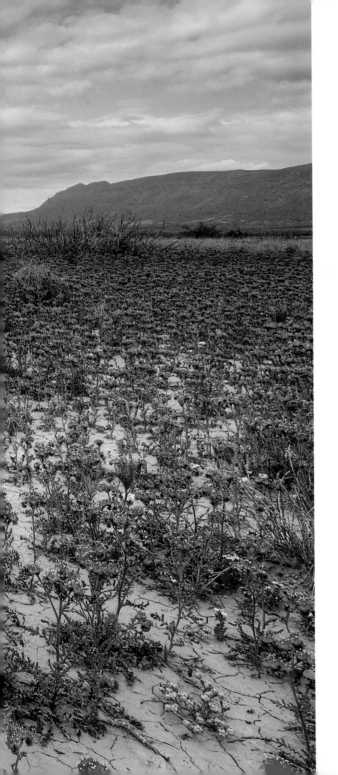

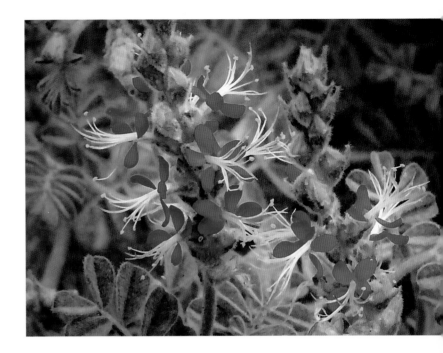

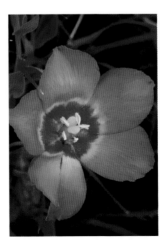

Above and left: It's hard to believe that some of the most delicate and beautiful flowers, such as the woolly prairie clover *(Dalea lanata)* shown above and the Texas bluebell *(Eustoma exaltatum var. russellianum)* on the left, can grow in such an inhospitable climate as Boquillas Canyon in Big Bend National Park. Temperatures in the canyon can easily reach 110°F in June, which was when this image was taken. Richard Reynolds

Far left: This field of blue curls *(Phaecelia congesta)* fills the flatlands near Big Bend's Chisos Mountains after a wet spring. Such vast displays of vivd color don't happen often in this desert, but when the rains come the wildflowers bloom, and the colors can be stunning. Rob Greebon

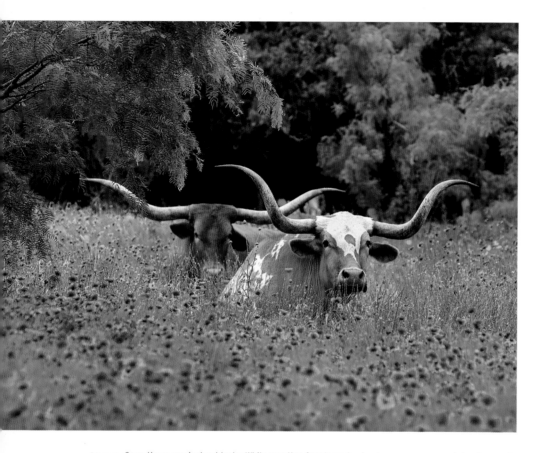

Above: Sometimes you just get lucky. While scouting for places to shoot on a gray, overcast day, I passed by a little stretch of Indian blankets near Llano and noticed two regal longhorns sitting in the field. I swung around, brought out the telephoto lens, and took several shots resulting in one of my favorite—and best-selling—Texas wildflower images. Rob Greebon

Right: With sun streaming through the leaves of a sprawling tree in the Texas Hill Country, Indian blankets *(Gaillardia pulchella)* and lazy daisies *(Aphanostephus ramosissimus)* catch the last rays of light on a late April evening. Landscapes such as this are common when the spring rains are frequent. Rob Greebon

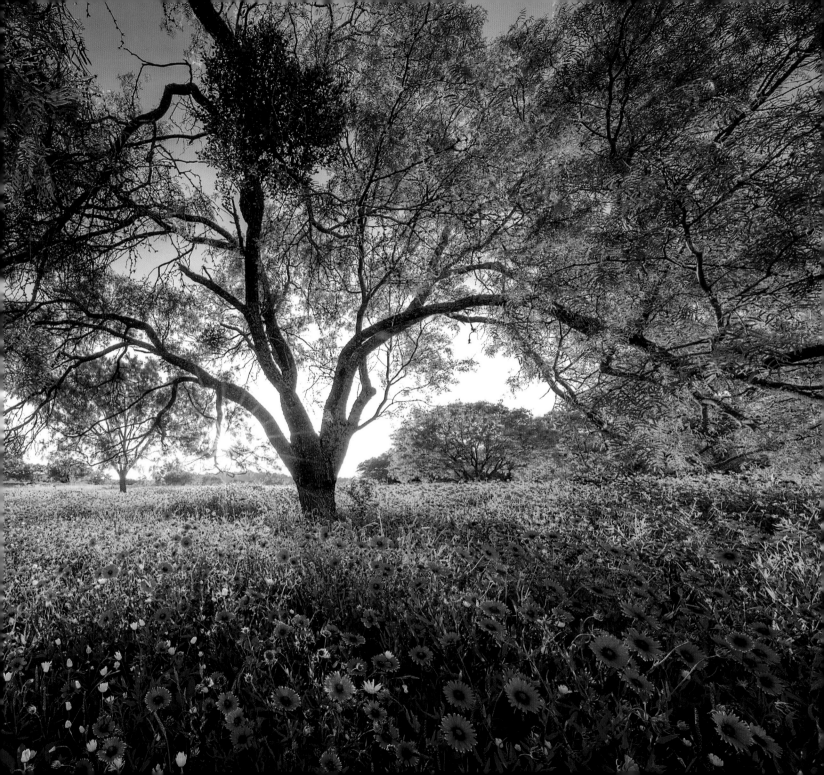

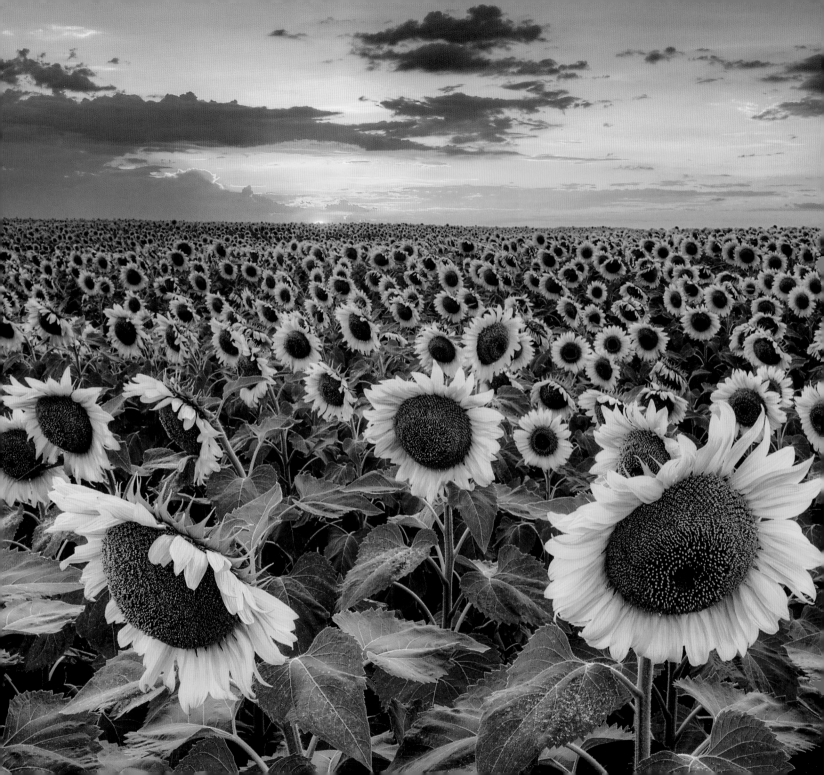

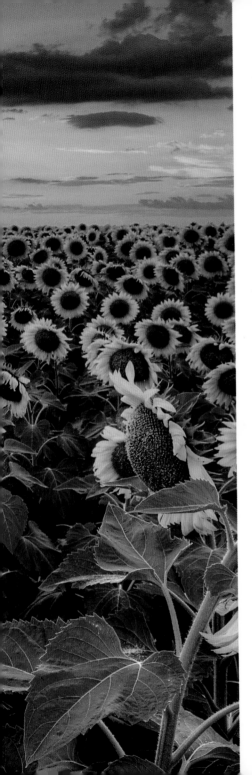

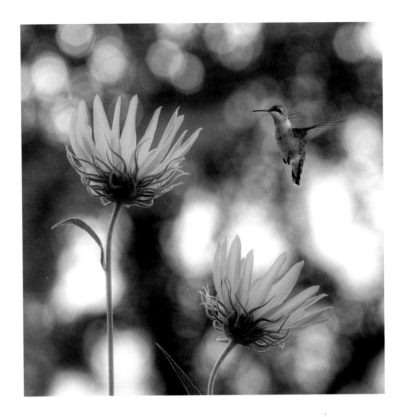

Above: From the backside of these Texas sunflowers *(Helianthus annuus var. texanus),* I set up my tripod and spent an hour (maybe longer) trying to catch this little humming-bird in flight. I took about fifty images with my 100mm lens in hopes of capturing one clear photograph. The Texas Hill Country offers so many opportunites to photograph intimate scenes—it often just takes patience. This hummer, framed in the morning light, was my reward. Rob Greebon

Left: I found this amazing field of sunflowers *(Helianthus annuus)* near Hillsboro, Texas. Though it's three hours from my house, I made the drive several times to this location, always hoping for a good sunset. Much to my wife's chagrin, on this occasion I even brought along our coffee table to gain a little more height and shoot over the flowers. Persistence paid off, and the evening rewarded my efforts with a colorful sky. Rob Greebon

Right: A bloom like this with horsemint *(Monarda citriodora)*, Indian blanket *(Gaillardia pulchella)*, and woolly paperflower *(Psilostrophe tagetina)* in Palo Duro Canyon is special. As I took advantage of the calm winds to get this long exposure at sunrise, the hordes of mosquitos living among the flowers took the opportunity to attack me. Fortunately, I came away with the shot despite receiving dozens of mosquito bites. Richard Reynolds

Below: My daughter accompanied me on this short trip near our home in the Hill Country to photograph the flowering purple horsemint. She stood behind me, her butterfly net ready for action. I fended her off long enough to capture this delicate creature as it searched for nectar. Rob Greebon

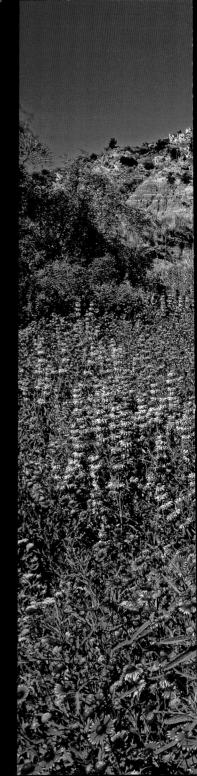

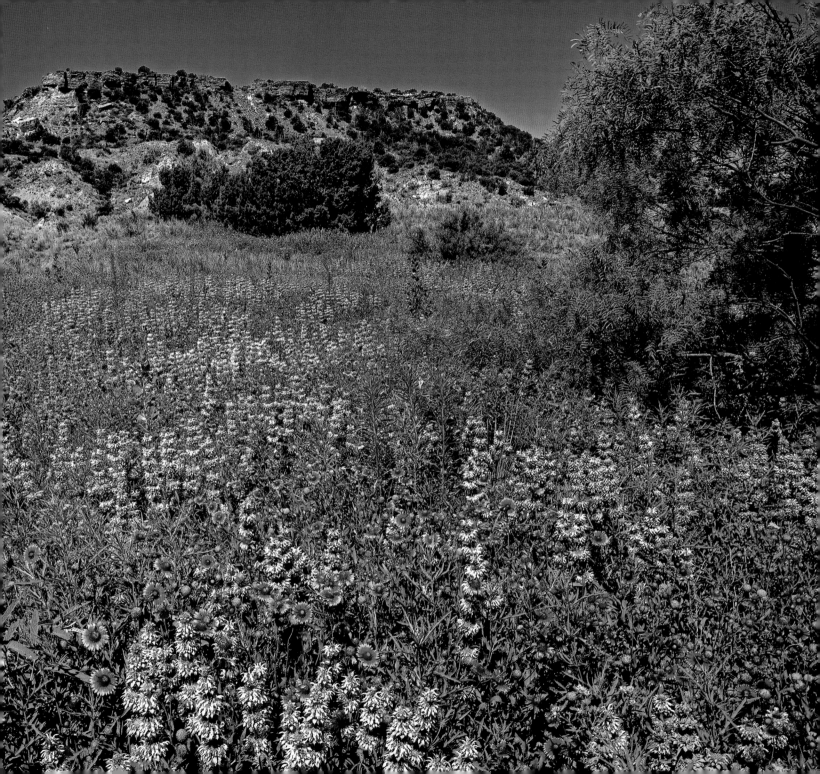

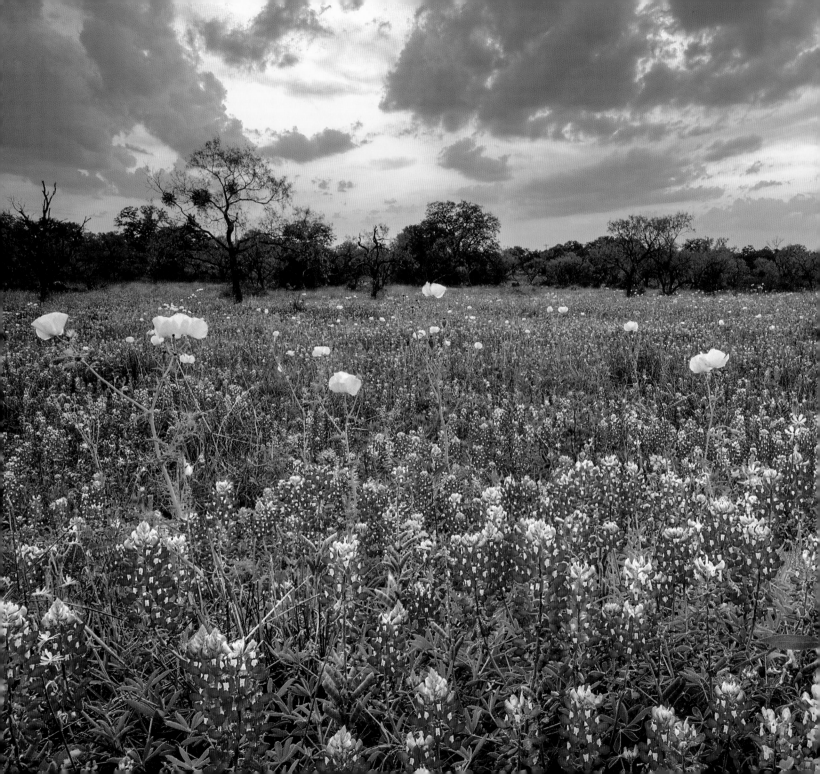

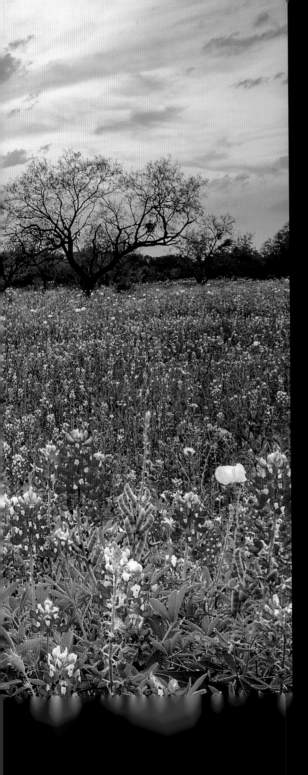

Left: Along a little dirt road near Mason in the Hill Country, a field of bluebonnets and white prickypoppies *(Argemone albiflora var. texana)* spread out under the rays of a setting sun. When the sky started showing these bands of light, I frantically searched for a spot to pull over and take a few images. Climbing on top of my SUV with the tripod and camera in tow, I reeled off several shots before the light faded into a dull blue-gray once again. Rob Greebon

Next pages: Chasing the light, I was driving down to the western slope of the Chisos Mountains late one spring evening. To the south, storms were moving in fast across the Chihuahuan Desert, and the lightning and thunder made my fingers move just a bit more quickly as I tried to capture the beauty of this prickly pear bloom *(Opuntia sp.)* in the foreground as crazy light filled the evening skies. Rob Greebon

Below: Driving back from photographing wildflowers one morning near Round Mountain, I noticed several deer off in a field of bluebonnets and white pricklypoppies. I drove past the location so as not to scare them, stopped and switched to a telephoto lens, then walked back down the dirt road and captured this single image before the deer bounded away and out of sight. Rob Greebon

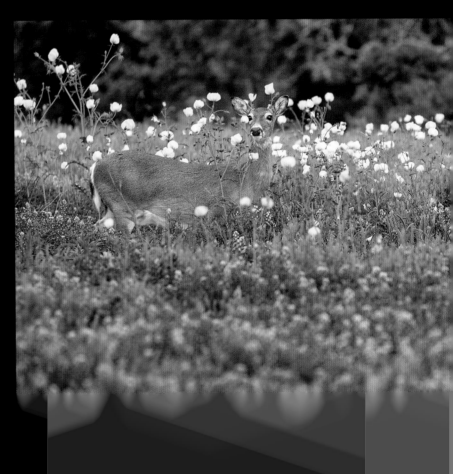

PHOTOGRAPH A GREAT WILDFLOWER LANDSCAPE
by Rob Greebon

In classes I've taught, I'm asked what makes a good landscape photograph. Everyone has an opinion, and there really isn't a right or wrong answer. I know what I look for in my own work, as well as what I enjoy when viewing other photographers' images.

The basics for all landscapes, including wildflowers, are essential—correct exposure, intended focus, and the rule of thirds. Next, I look for leading lines. I like lines, angles, curves—anything that leads the eye to the subject of the image. I also want those lines and angles, whenever possible, to intersect with the corners of the image. These lines could be composed of roads, water, buildings, rocks, wildflowers, or anything that allows the eye to flow to its intended target.

Within the composition of my own images, I look for three main elements. First, I want a foreground element to capture interest. Whether a bluebonnet or prickly pear cacti in bloom, I like to have a visual element up close to show detail. For this, I'll often shoot several images of varying depths from front to back and blend them together to obtain sharpness throughout the photograph. Other foreground elements could in-

clude rock formations, trees, logs, and even silhouetted people. These foreground elements can also serve as leading lines when positioned correctly.

Next, I want the background of the photograph to serve some purpose. This area might be a field of wildflowers or backdrop of mountains. In any case, I want this element sharp, and I may work with several images varying in depth and in combination with the foreground elements to make sure I have a detailed and sharp perspective.

Last, a sky with interesting, if not dramatic, clouds is a must. I shoot mostly at sunrise or sunset and always hope for pleasing colors, but even a nice blue sky with high wispy clouds can complement an interesting foreground. I also always know when and where the moon will appear. The appearance of the moon can enhance an otherwise dull sky.

When all of these factors are taken into account, you have the potential for a strong image. That being said, the most important aspect of a photograph is the impact it has on the viewer. Does it tell a story, evoke an emotion, or capture a beautiful moment? If so, in my opinion, it is a successful endeavor.

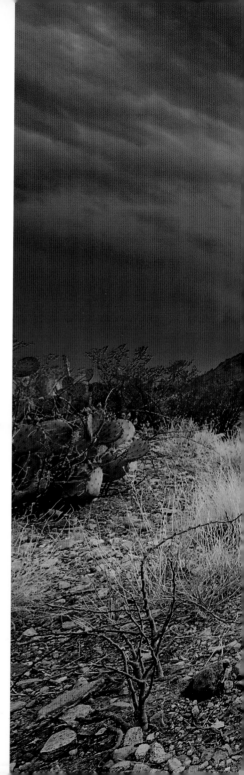

Rob Grebon

Grebon is a forth generation Texan who resides just outside of Austin in the Texas Hill Country with his wife and two daughters. As a self-taught photographer, Rob has successfully transitioned his love of the outdoors into an award-winning photography business. His work has been published internationally and appears regularly in local and national publications, television, many corporate and private collections, and the book *Austin: A Photographic Journey.*

As an admitted morning person, he enjoys the solitude and beauty that comes with a quiet sunrise, whether it's from a highrise in Austin or a remote spot in the Texas Hill Country.

You can find more of Rob Grebon's photographs from Texas at www.ImagesfromTexas.com.

Richard Reynolds

© MICHAEL MURPHY

Reynolds earned a degree in industrial photography and color technology at the prestigious Brooks Institute of Photography in Santa Barbara, California. He was formerly chief photographer for the Texas Tourist Development Agency and the Tourism Division of the Texas Department of Commerce. His photographs have appeared in numerous state, national, and international publications including *National Geographic Traveler, Newsweek, Outside Magazine, Texas Monthly, Reader's Digest, Southern Living, Vista, Geo* (France), and textbooks published by Harcourt Book Publishers and Houghton Mifflin. He has been a regular contributor to *Texas Highways* magazine for almost 30 years, with 28 covers to his credit. In addition, his work has appeared in dozens of calendars by Sierra Club, Westcliffe Publishers, Brown Trout, Golden Turtle, and Shearson Publishing. He is also the photographer of nine other books: *The Green Pastures Cookbook; Texas, Images of Wildness; Texas Reflections; Texas Wildflowers; Texas Hill Country; A Texas Christmas; Texas, Then and Now; Wild Texas; Do You See What I See?* (Texas), and four self-published books: *Flower; Cactus; Butterfly;* and *Earth, Sky, and Water: The Landscape Photographs of Richard Reynolds, 1976-2013.* He is also the co-photographer of two other books with Farcountry Press: *Texas Impressions* and *Big Bend Impressions.*

You can view additional photographs by Richard Reynolds at www.richardreynolds.photoshelter.com.